Remembering
Houston

Betty Trapp Chapman

TURNER
PUBLISHING COMPANY

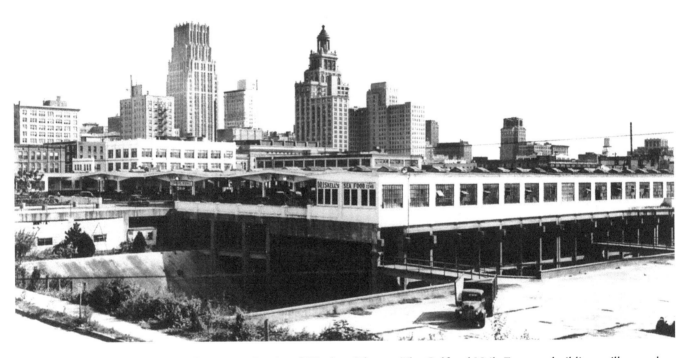

Farmers' Market, built in 1928 on the present-day site of Wortham Theatre. The Gulf and Neils Esperson buildings still topped the skyline in the 1940s.

Remembering
Houston

Turner Publishing Company
4507 Charlotte Avenue • Suite 100
Nashville, Tennessee 37209
(615) 255-2665

Remembering Houston

www.turnerpublishing.com

Library of Congress Control Number: 2010923493

ISBN: 978-1-59652-623-5
ISBN-13: 978-1-68442-298-2 (pbk)

Printed in the United States of America

CONTENTS

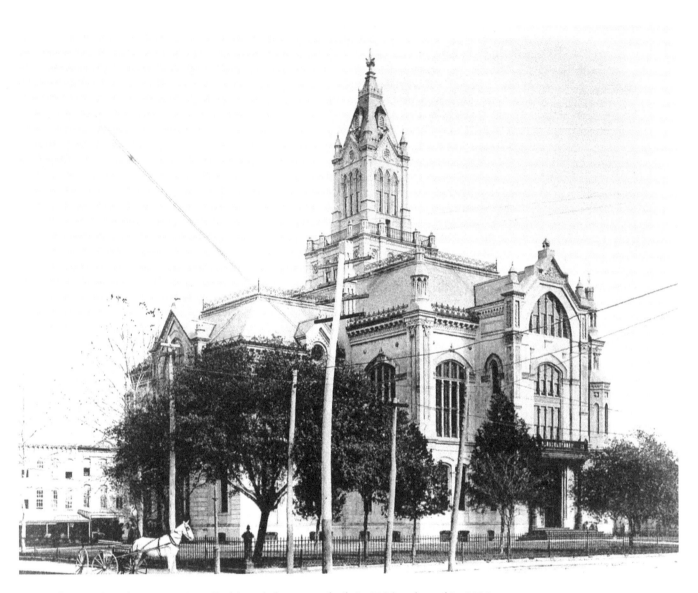

Harris County Courthouse, a unique Gothic-styled structure built in 1884 and razed in 1909.

ACKNOWLEDGMENTS

This volume, *Remembering Houston,* is the result of the cooperation and efforts of many individuals and organizations. It is with great thanks that we acknowledge in particular the valuable contribution of the Houston Public Library–Houston Metropolitan Research Center.

We would also like to thank:

Betty Trapp Chapman, historian, for organizing, researching, and writing this history
Joel Draut, archival photographer at the Houston Metropolitan Research Center
Barfield Photography

PREFACE

Houston has thousands of historic photographs that reside in archives, both locally and nationally. This book began with the observation that, while those photographs are of great interest to many, they are not easily accessible. During a time when Houston is looking ahead and evaluating its future course, many people are asking, How do we treat the past? These decisions affect every aspect of the city—architecture, public spaces, commerce, infrastructure—and these, in turn, affect the way that people live their lives. This book seeks to provide easy access to a valuable, objective look into the history of Houston.

The power of photographs is that they are less subjective than words in their treatment of history. Although the photographer can make subjective decisions regarding subject matter and how to capture and present it, photographs seldom interpret the past to the extent textual histories can. For this reason, photography is uniquely positioned to offer an original, untainted look at the past, allowing the viewer to learn for himself what the world was like a century or more ago.

This project represents countless hours of review and research. The researchers and writer have reviewed thousands of photographs in numerous archives. We greatly appreciate the generous assistance of the archivists listed in the acknowledgments of this work, without whom this project could not have been completed.

The goal in publishing this work is to provide broader access to this set of extraordinary photographs that seek to inspire, provide perspective, and evoke insight that might assist people who are responsible for determining Houston's future. In addition, the book seeks to preserve the past with adequate respect and reverence.

With the exception of touching up imperfections that have accrued with the passage of time and cropping where necessary, no changes have been made. The focus and clarity of many images are limited to the technology and the ability of the photographer at the time they were recorded.

The work is divided into eras. Beginning with some of the earliest known photographs of Houston, the first section records photographs from before the Civil War through the end of the nineteenth century. The second section spans the first two decades of the twentieth century. The last section takes a look at a wide swath of time, spanning half the twentieth century from the 1920s to the early 1970s.

In each of these sections we have made an effort to capture various aspects of life through our selection of photographs. People, commerce, transportation, infrastructure, religious institutions, and educational institutions have been included to provide a broad perspective.

We encourage readers to reflect as they go walking in Houston, strolling through the city, its parks, and neighborhoods. It is the publisher's hope that in utilizing this work, longtime residents will learn something new and that new residents will gain a perspective on where Houston has been, so that each can contribute to its future.

—Todd Bottorff, Publisher

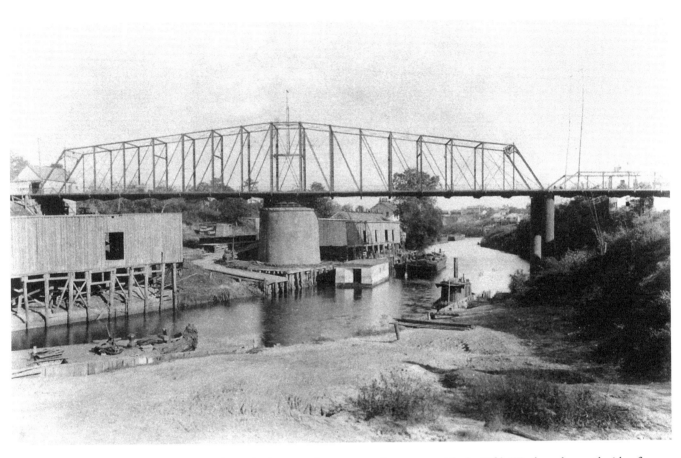

The San Jacinto Bridge, seen here in 1894, was built in 1886 to connect downtown with the Fifth Ward on the north side of Buffalo Bayou.

HOUSTON PLANTS ITS ROOTS

(1856–1899)

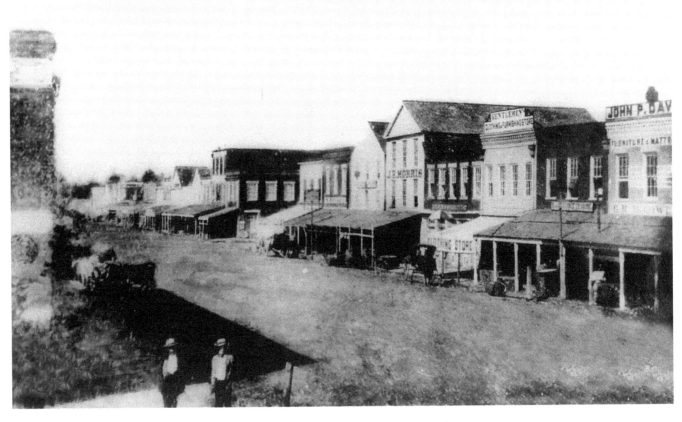

The earliest known photograph of Houston shows the 300 block of Main Street, 1856.

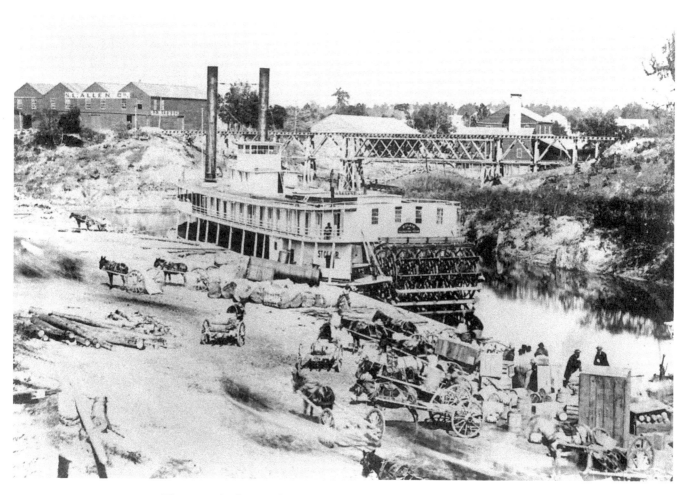

The sternwheeler *St. Clair* is loaded with cotton at the foot of Main Street shortly after the Civil War.

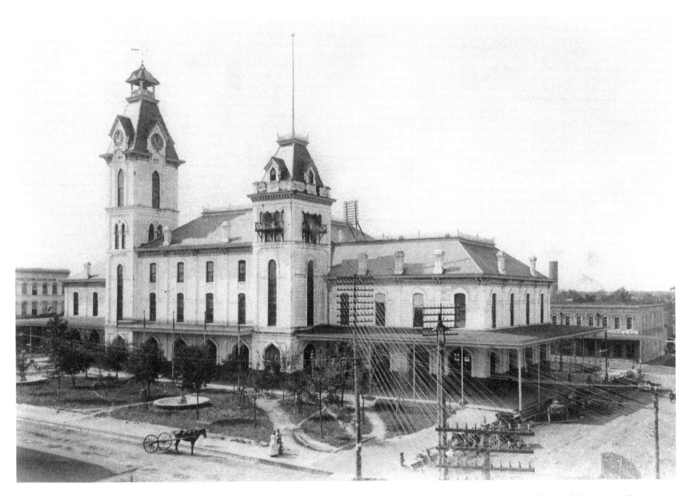

Market House held the farmers' market, offices of city government, the telephone exchange, and a circulating library until it was destroyed by fire in 1901.

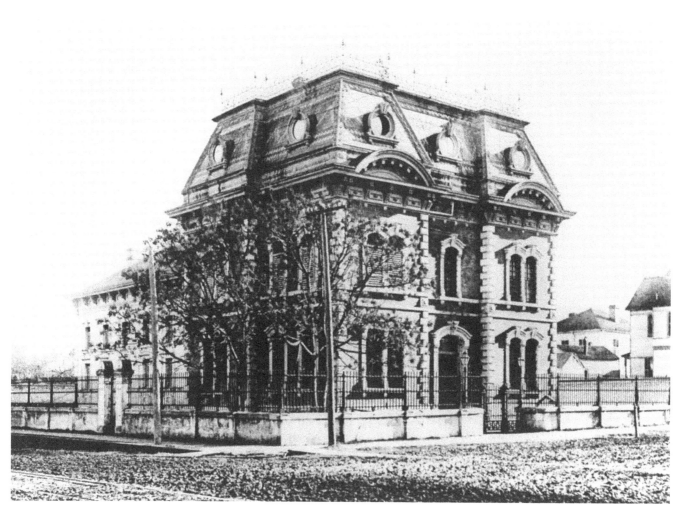

Harris County Jail, 1879.

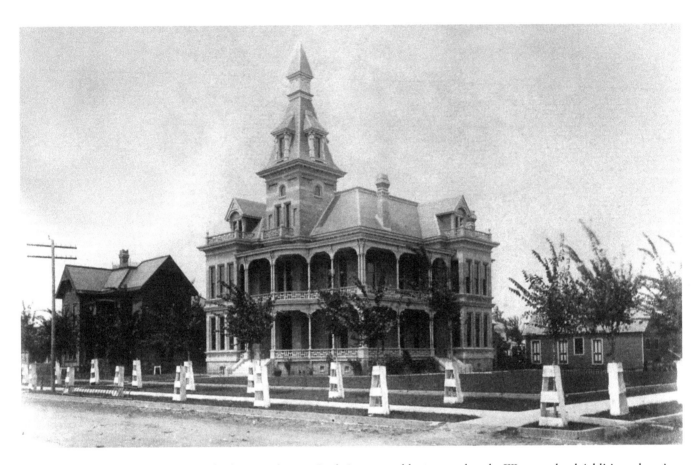

The Jedidiah Porter Waldo home was built in 1884-85 on Rusk Avenue and later moved to the Westmoreland Addition where it was redesigned by the family.

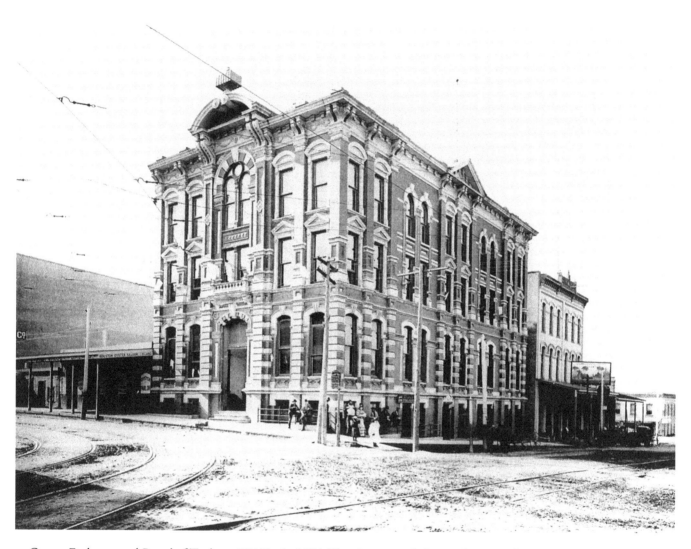

Cotton Exchange and Board of Trade, at 202 Travis, 1884. The zinc cotton bale served as a weather vane on top of the building.

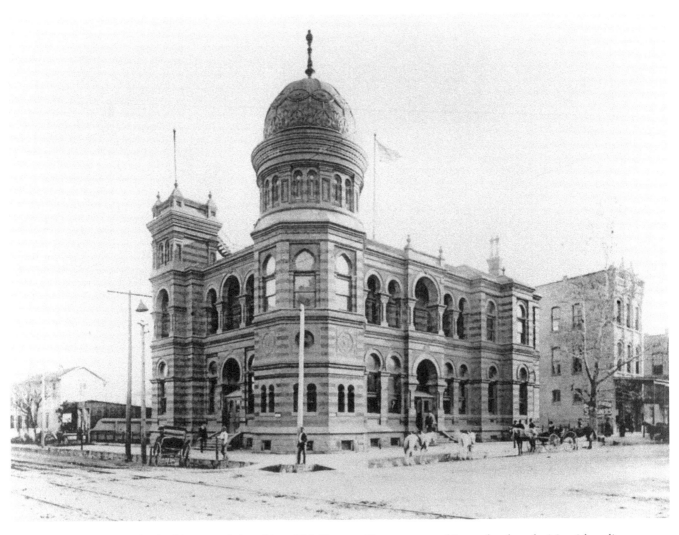

U.S. Post Office, 1888. This building was designed by a U.S. Treasury Department architect who thought Moorish styling was appropriate for Houston's warm climate.

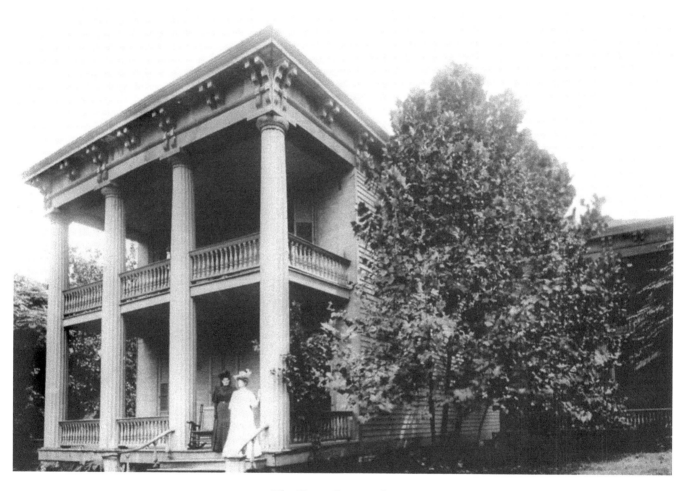

The Henry Sampson home on Preston Avenue across from Courthouse Square.

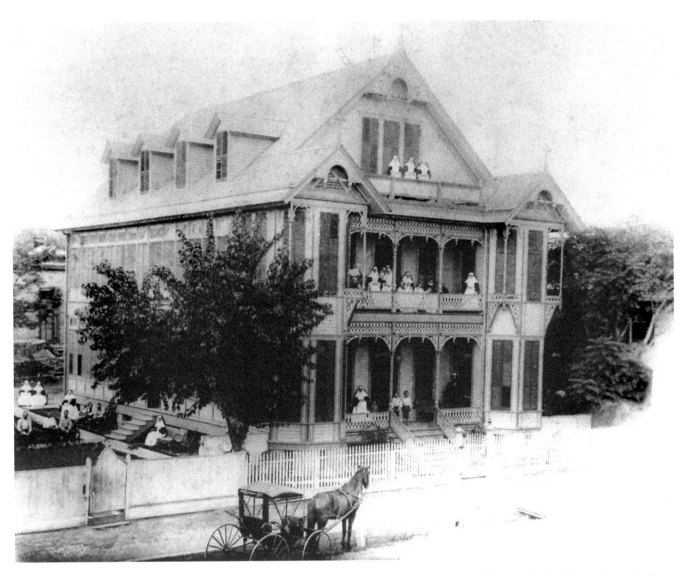

St. Joseph's Infirmary was founded in this building by the Sisters of Charity of the Incarnate Word in 1887. When it burned, the hospital (now St. Joseph Medical Center) was moved to the site it occupies today.

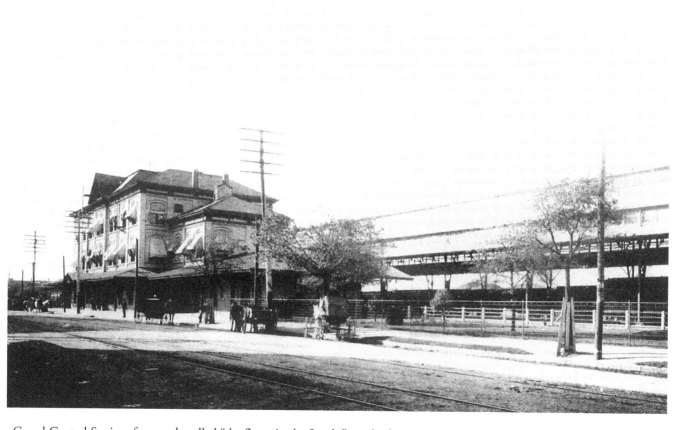

Grand Central Station, frequently called "the finest in the South," was built on Washington Avenue in 1887. The downtown post office occupies the site today.

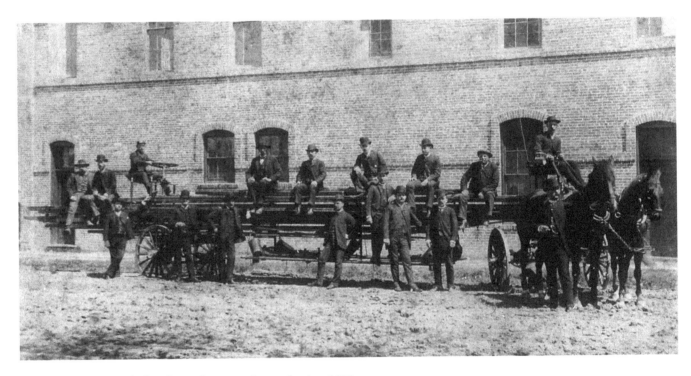

Volunteer firemen with their horse-drawn service truck, circa 1890.

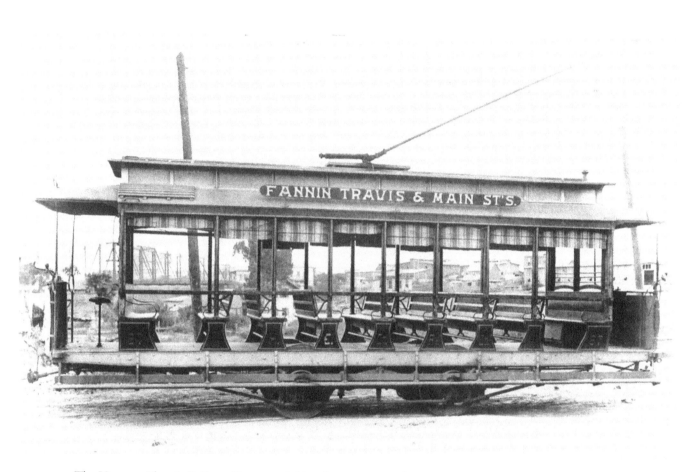

The Houston Electric Railway Company initiated service on tracks, which extended from downtown to the South End, June 12, 1891.

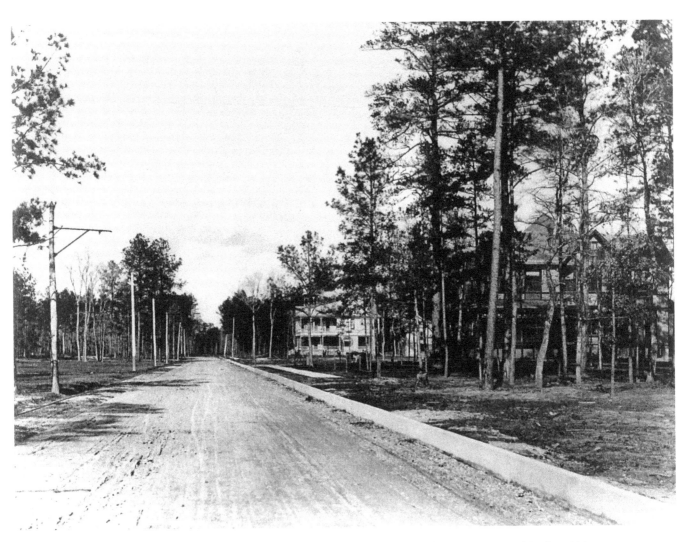

Heights Boulevard in Houston Heights, the first suburban development, is shown here as it appeared in the 1890s.

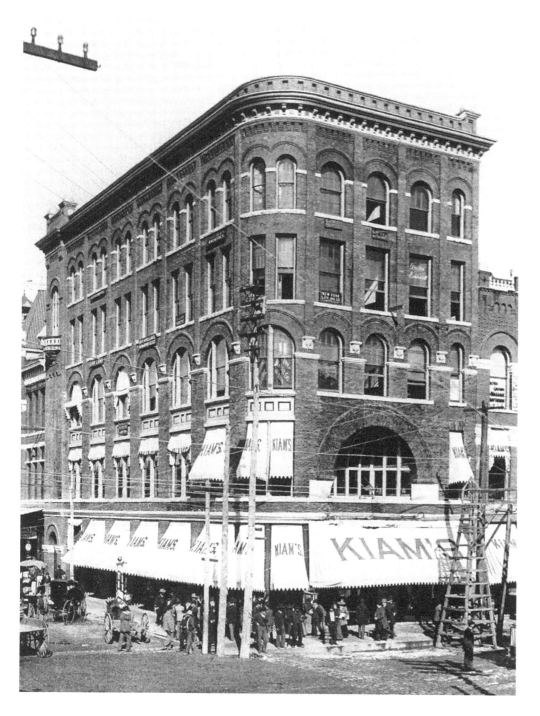

Kiam's clothing store was the first building in the city with an electric passenger elevator. Kiam's appears to be doing a brisk business here in 1893.

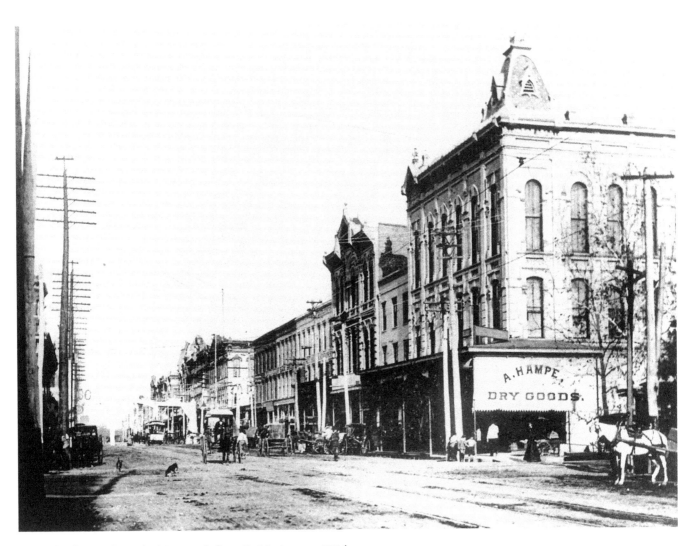

East side of Main Street looking north from Prairie Avenue, 1894.

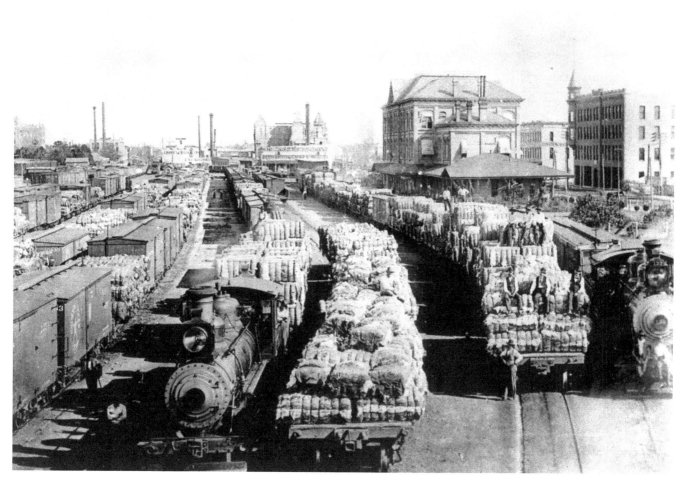

Flat cars loaded with cotton at Grand Central Station, 1894.

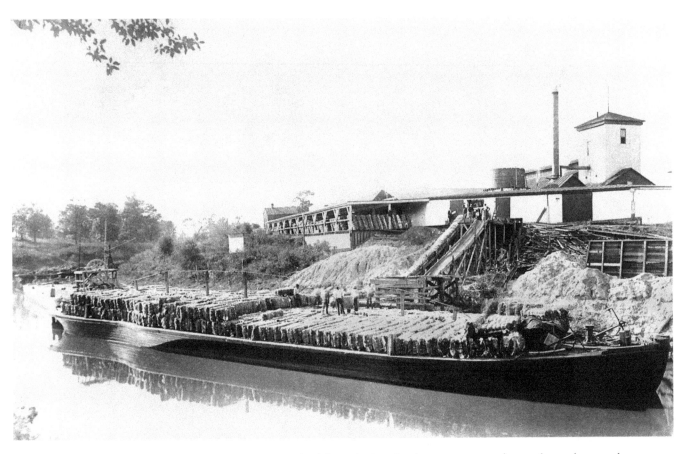

Bayou City Cotton Compress, 1890s. As cotton was received from the interior, it was compressed, sent down chutes to barges on the bayou, and then carried to ocean-bound vessels in Galveston.

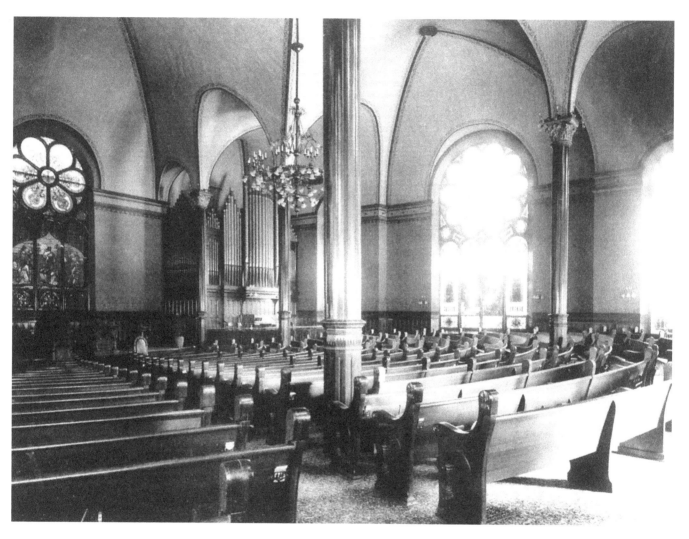

First Presbyterian Church was considered one of the most beautiful church interiors in the South when it was built in 1894.

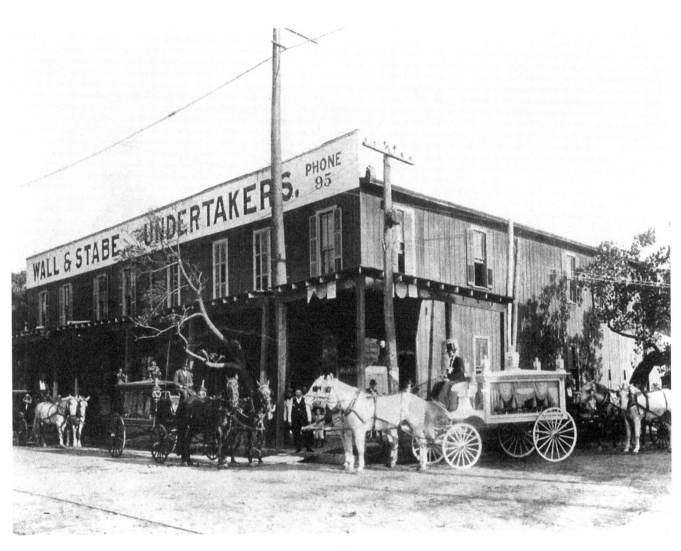

Wall and Stabe Undertakers, corner of Prairie and San Jacinto, 1895.

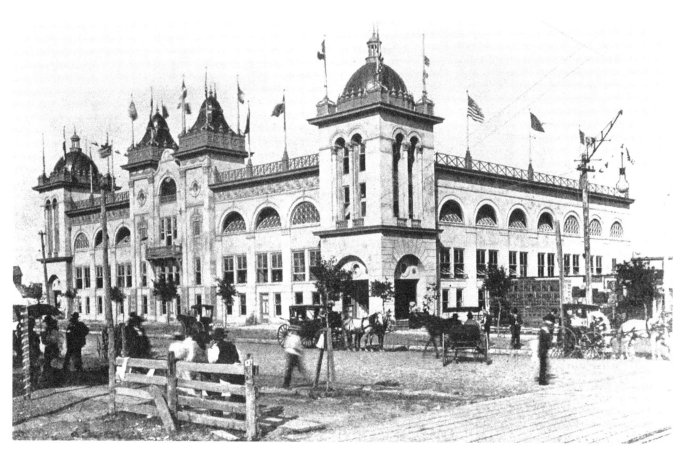

Winnie Davis Auditorium was built at Main and McGowen to accommodate a national reunion of Confederate veterans, 1895.

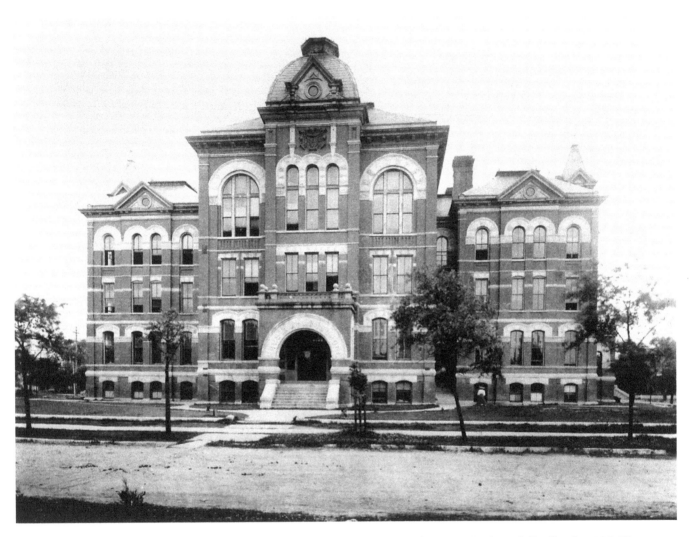

Houston High and Normal School occupied an entire block bounded by Capitol, Austin, Rusk, and Caroline in 1895. The building, later renamed Central High School, burned in 1919.

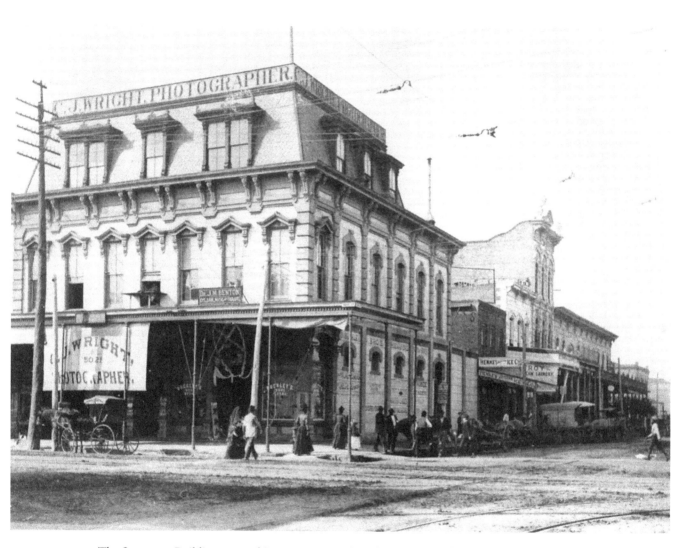

The Stegeman Building, erected in 1879 at 502 Main Street, is one of the oldest structures remaining downtown.

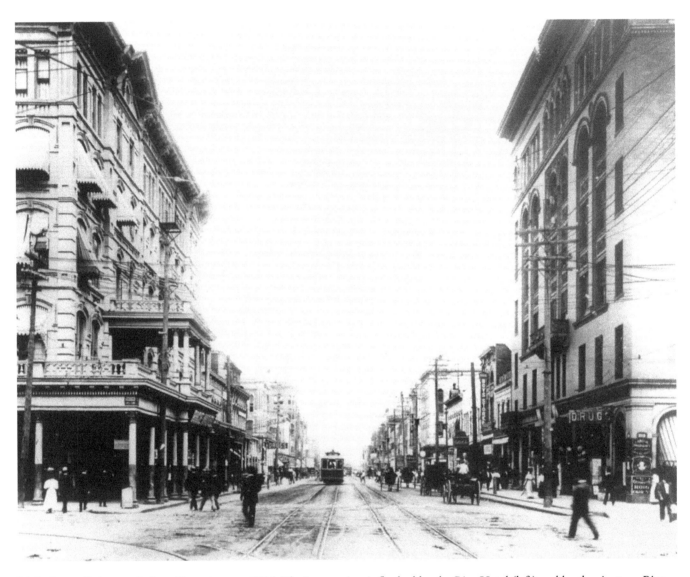

Main Street, facing north from Texas Avenue, 1904. The intersection is flanked by the Rice Hotel (left) and by the six-story Binz Building (right), considered Houston's first skyscraper when it was built in 1895.

Houston Matures
(1900–1920)

First National Bank at the corner of Main and Franklin, 1902. Fruit and cold lemonade were being sold from the sidewalk stand.

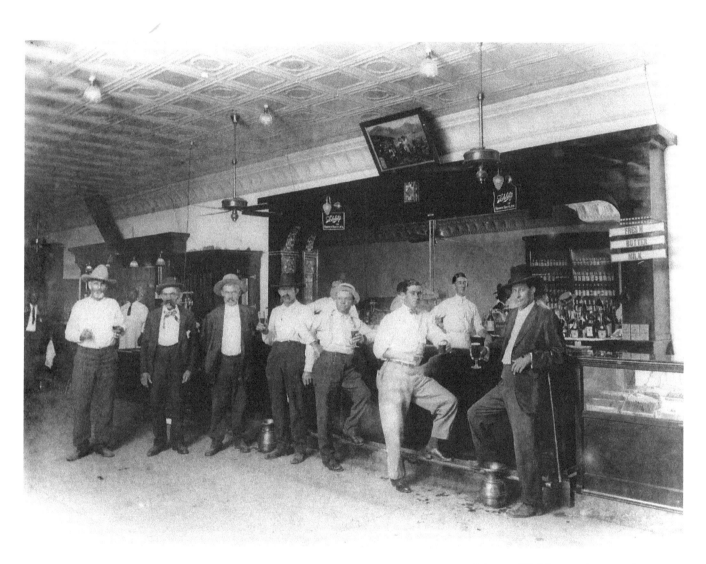

A bar on Washington Avenue, circa 1900.

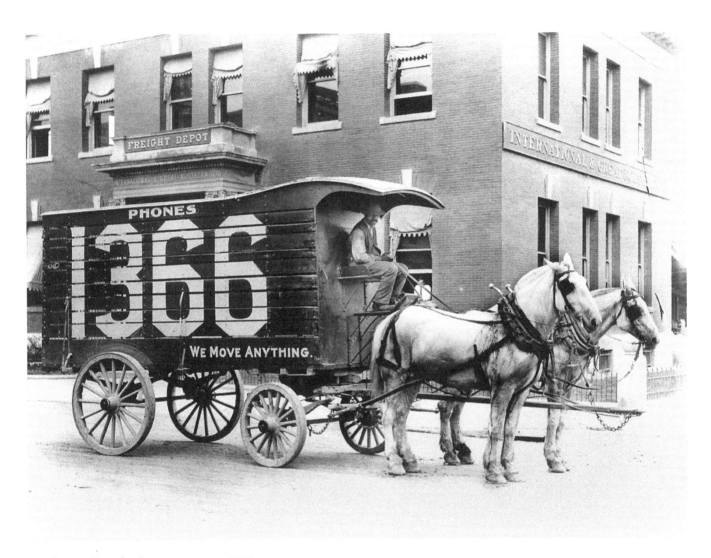

Westheimer Transfer Company wagon, 1900.

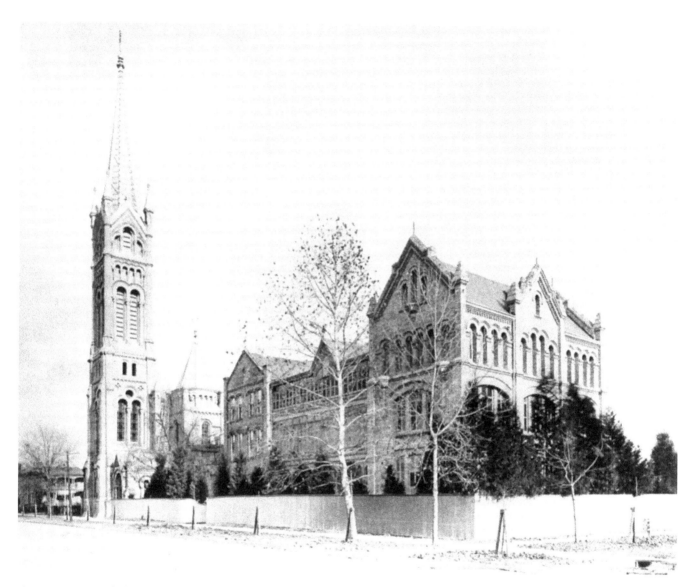

Annunciation Catholic Church and Incarnate Word Academy, circa 1900. The church structure dates to 1871 with later additions and remodeling by noted Galveston architect N. J. Clayton. Annunciation's steeple was the tallest point on the skyline until 1912.

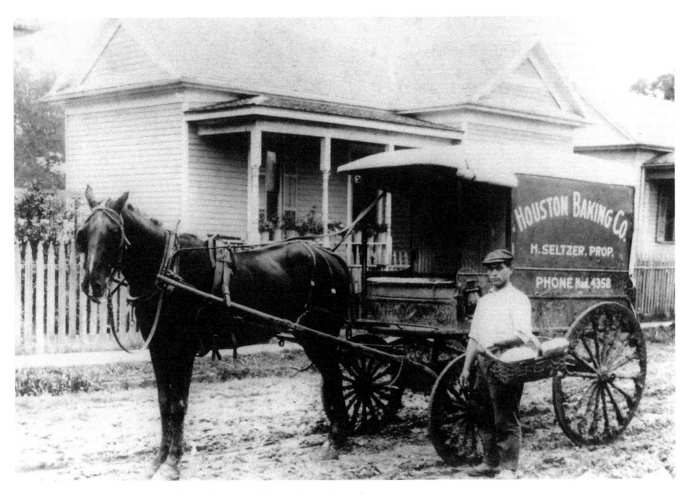

An employee of the Houston Baking Company delivers its products by wagon.

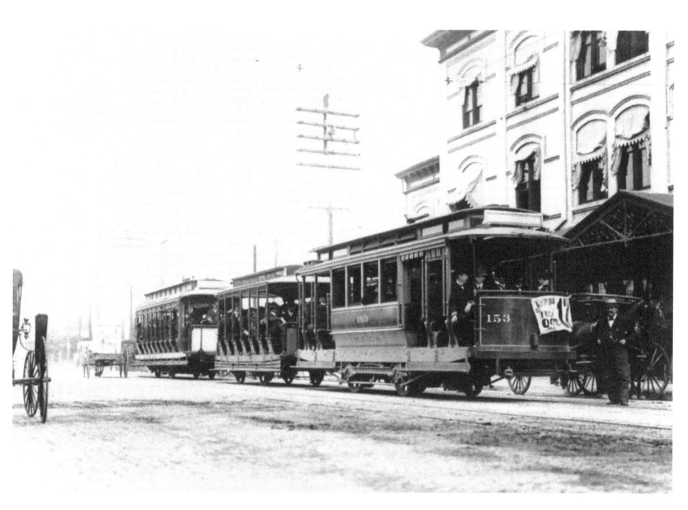

Streetcars leave Grand Central Station with a party of Ohio businessmen visiting the city in 1902.

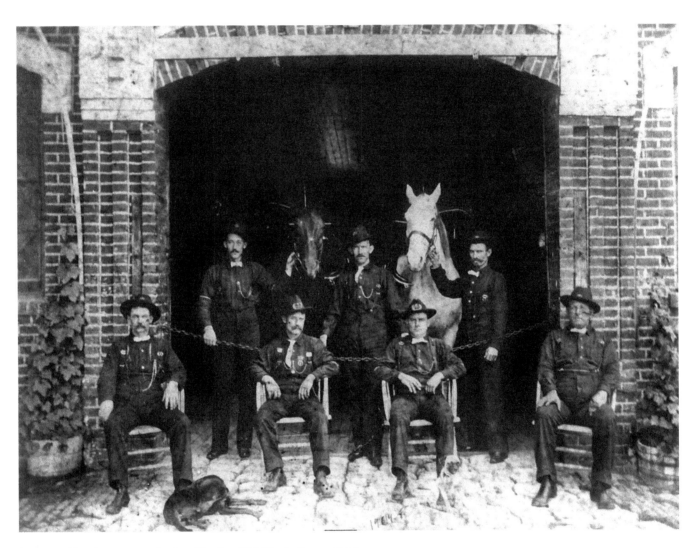

Houston Fire Department Station No. 5 at 910 Hardy Street, 1904.

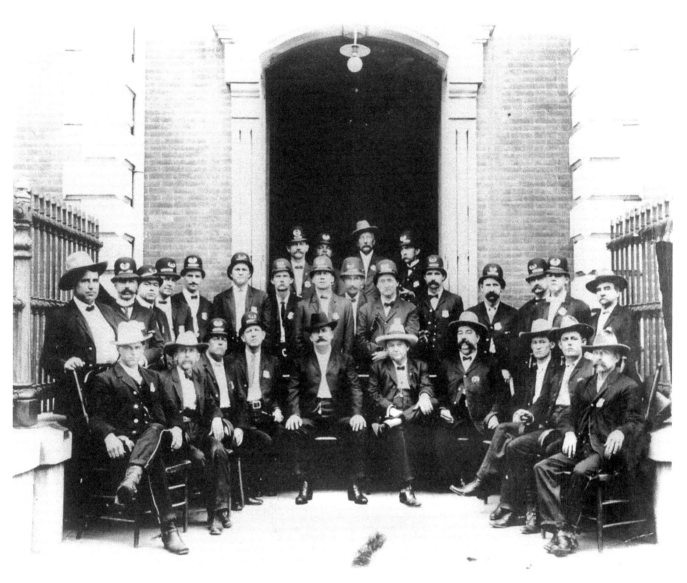

Houston Police Department in front of its headquarters on Caroline Street, 1903.

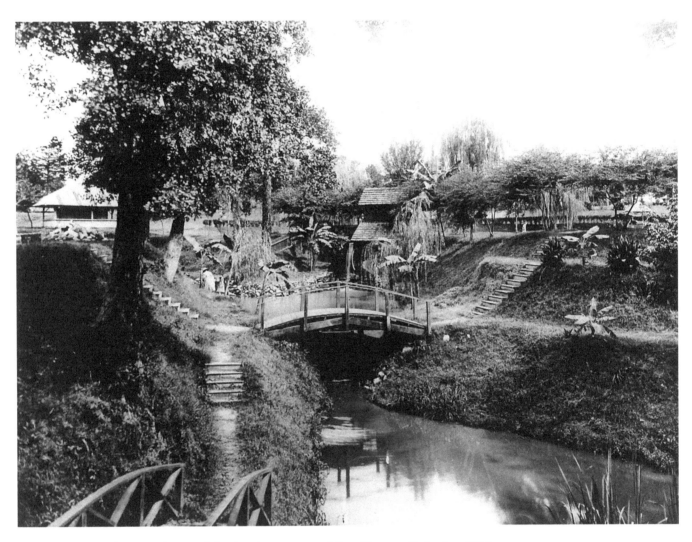

Lavishly landscaped City Park around the time it was renamed Sam Houston Park, circa 1903.

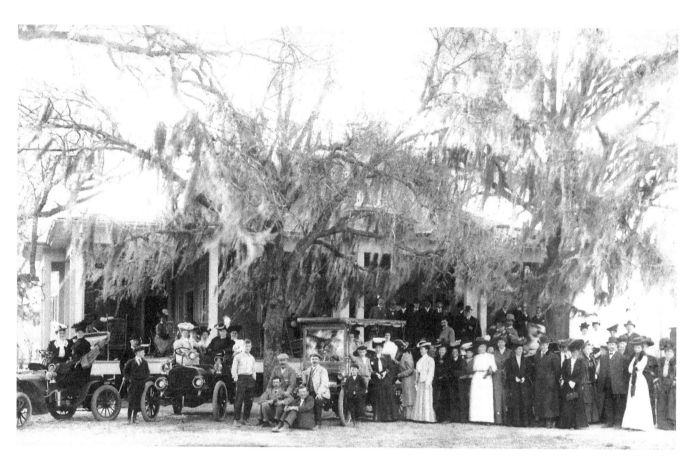

Houston Golf Club on the south side of Buffalo Bayou near San Felipe Road, circa 1904. The membership changed its name to Houston Country Club in 1908 and relocated to a site near Brays Bayou southeast of downtown.

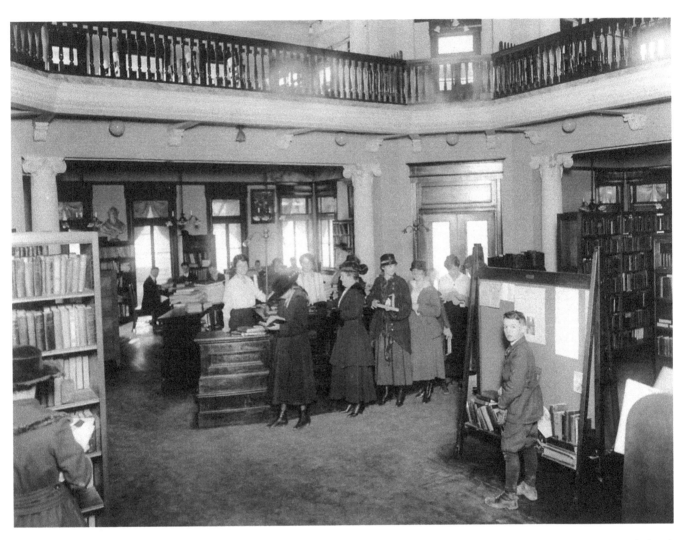

Check-out time at the newly opened Houston Lyceum and Carnegie Library, 1904. Longtime librarian Julia Ideson is seen behind the circulation desk.

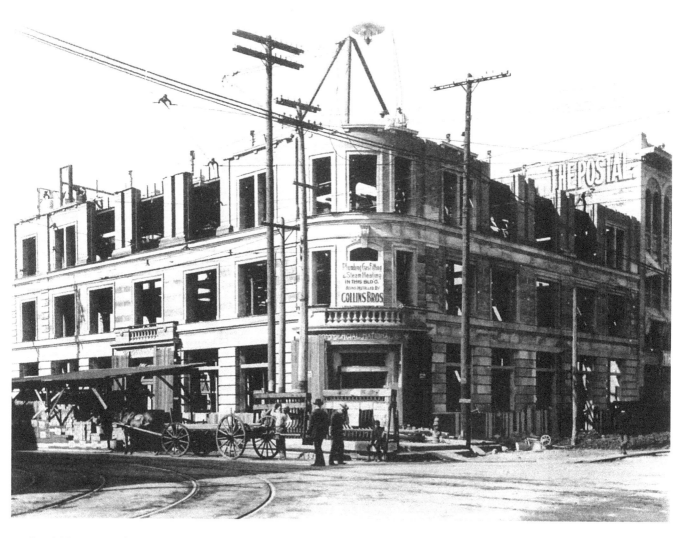

In 1905, construction is in progress on Commercial National Bank at the corner of Main and Franklin in the heart of the city's financial district.

Oil gushers were a common sight in the early 1900s.

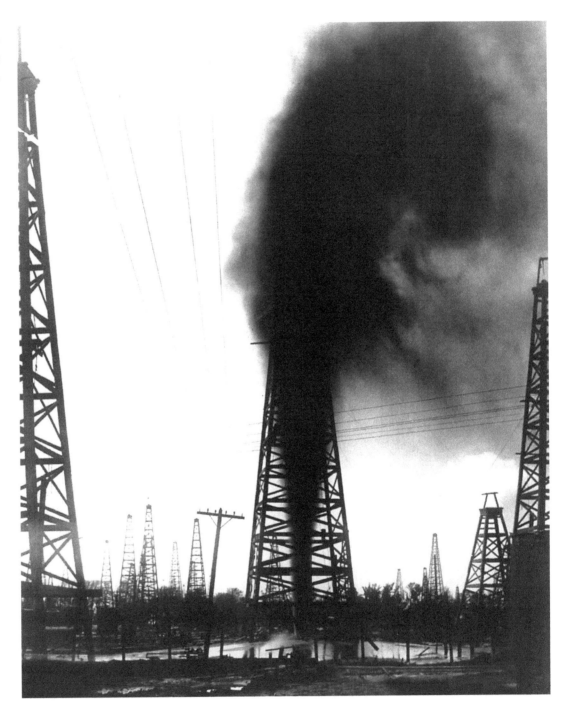

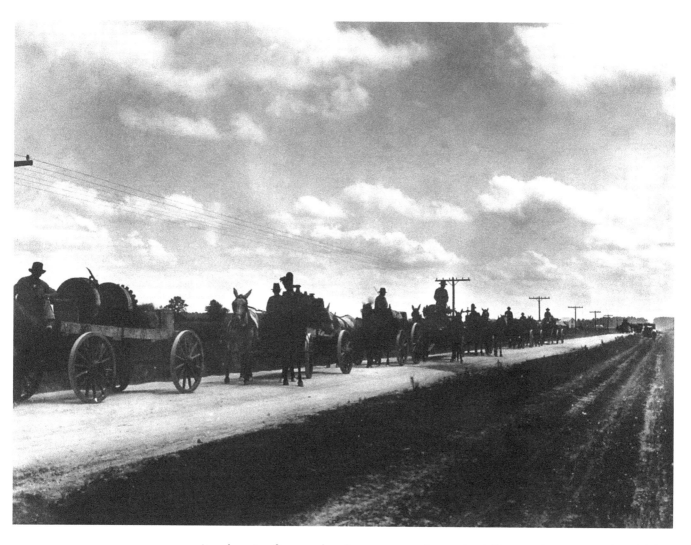

A mule train of men and equipment moves along a South Texas road en route to the oil fields.

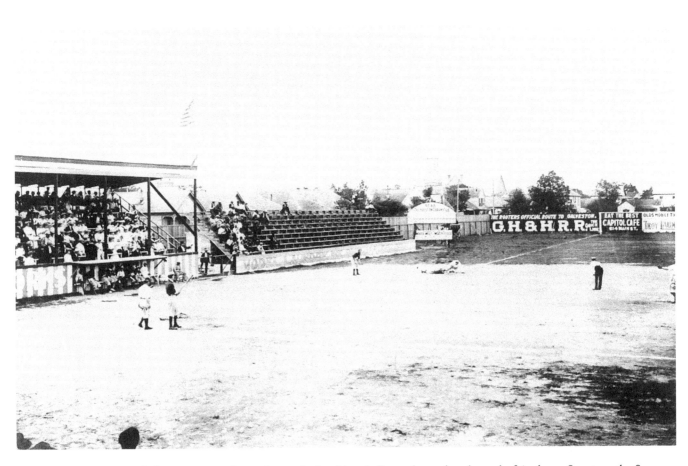

West End Park, Houston's first permanent home for professional baseball, was located at the end of Andrews Street on the San Felipe streetcar line. The steeple of Antioch Missionary Baptist Church is visible in the background.

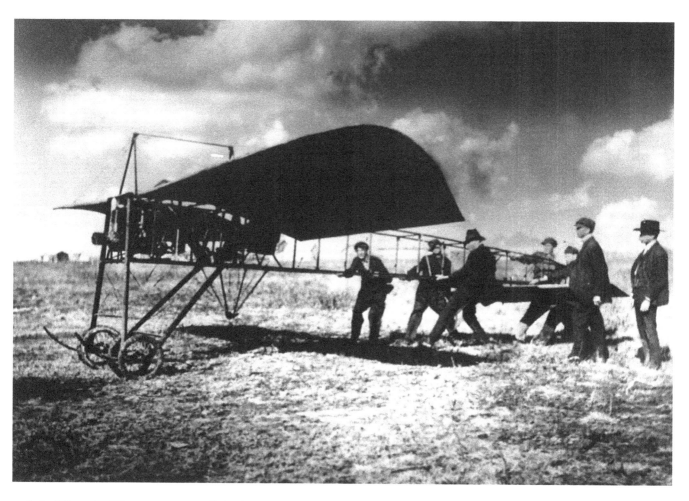

L. L. "Shorty" Walker, preparing to fly his homemade airplane on a field in South Houston, 1911. Walker built his plane on the top floor of the Auto and Motorworks Building, removed its wings to take it down on the freight elevator, and towed it to the field for the trial flight.

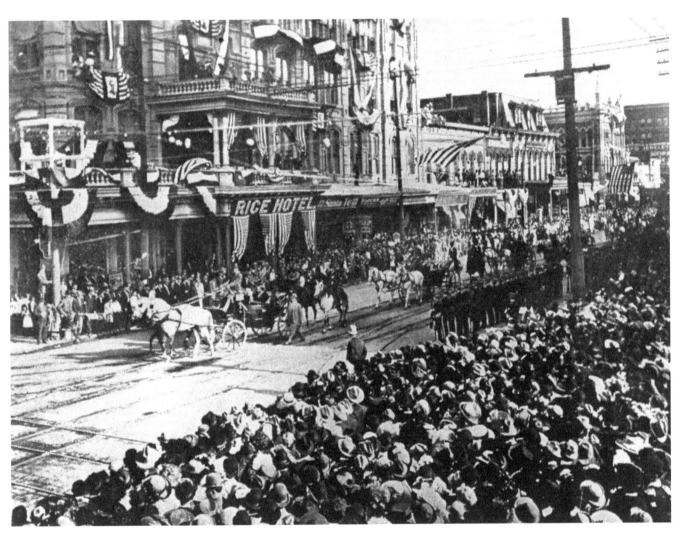

President William Howard Taft's procession down Main Street comes into view during his visit to the city in November 1909.

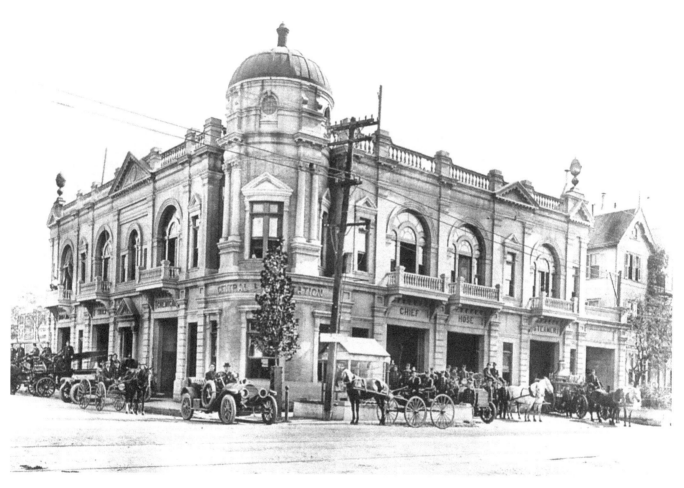

Houston Fire Department's Central Station, 1910.

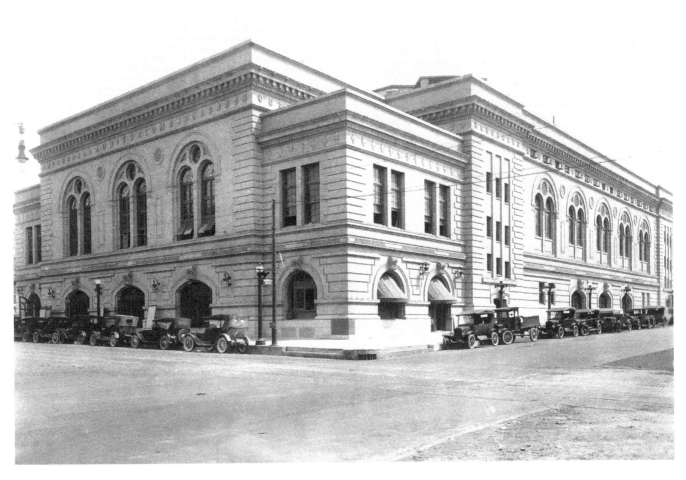

City Auditorium, built in 1910, was the site of concerts, trade shows, conventions, dramatic performances, and wrestling matches for 50 years. It was razed in 1963 for the construction of the Jesse H. Jones Hall for the Performing Arts.

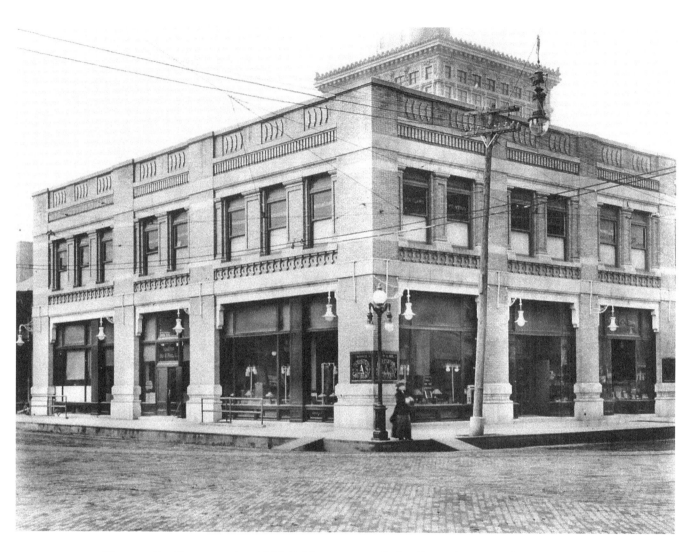

Houston Gas Company, circa 1912. Brick streets prevailed well into the twentieth century in the downtown area.

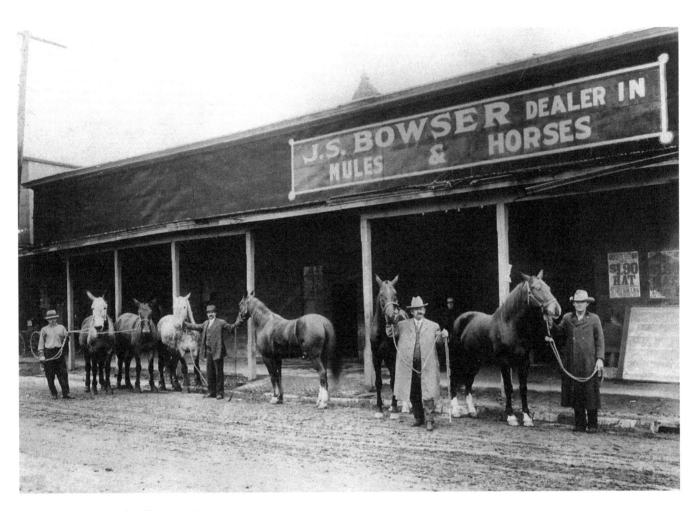

J. S. Bowser Livery, 611 Preston, 1911.

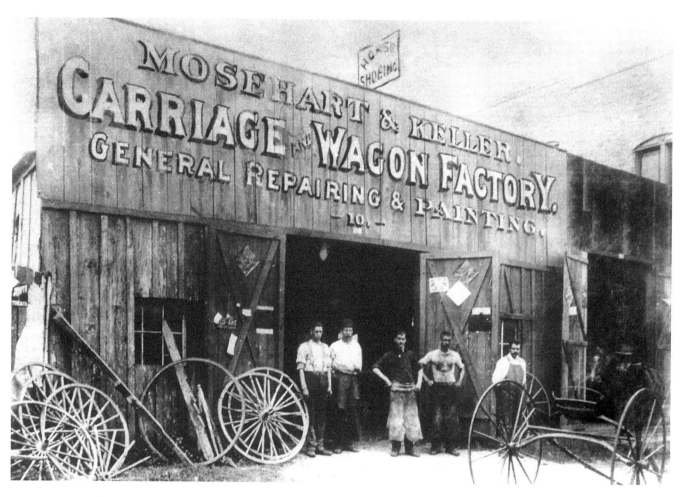

Mosehart and Keller Carriage and Wagon Factory, 1910. The business soon made the transition to selling automobiles.

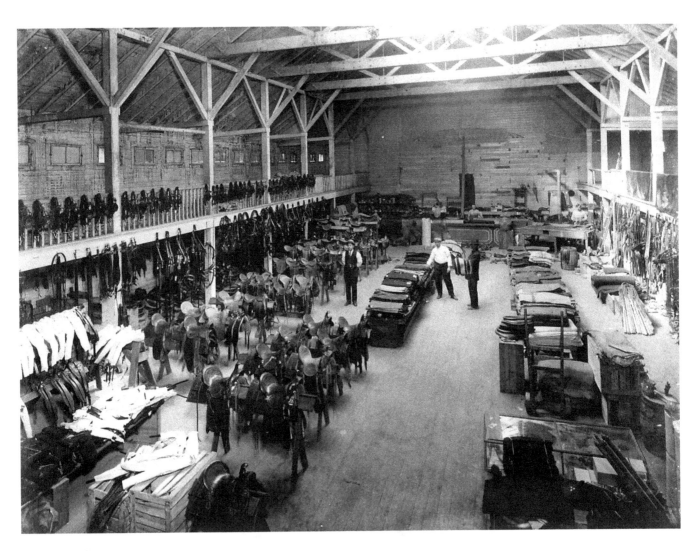

Stelzig's Saddlery, 1911.

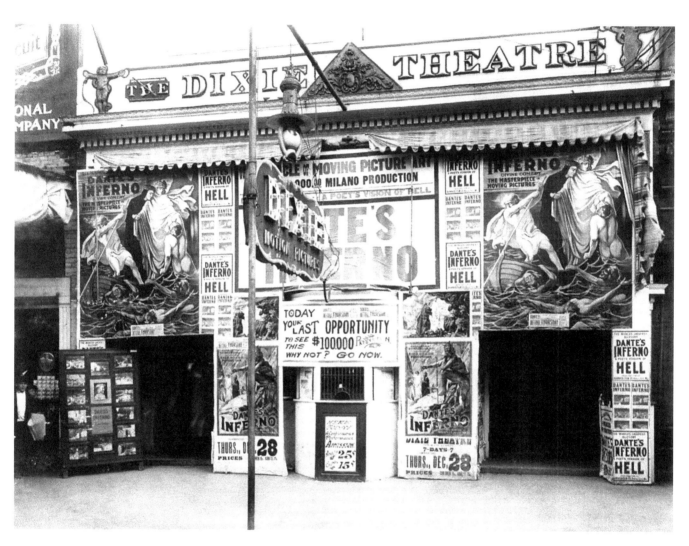

The Dixie Theatre, 603 Main Street, 1911.

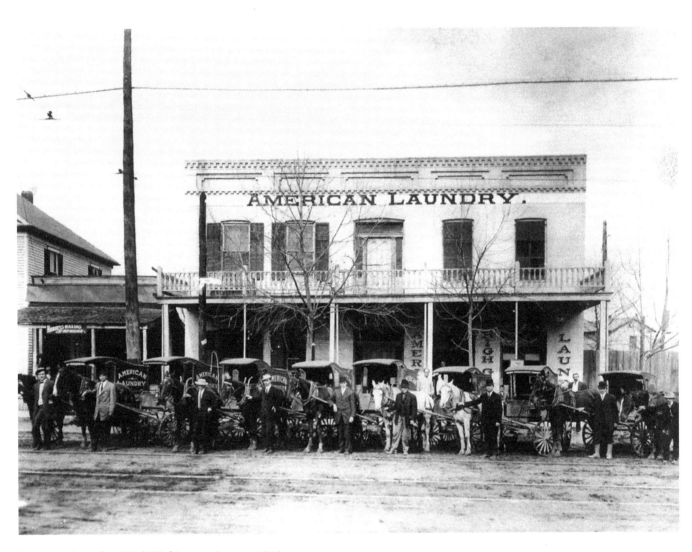

American Laundry, 1304 Washington Avenue, 1910.

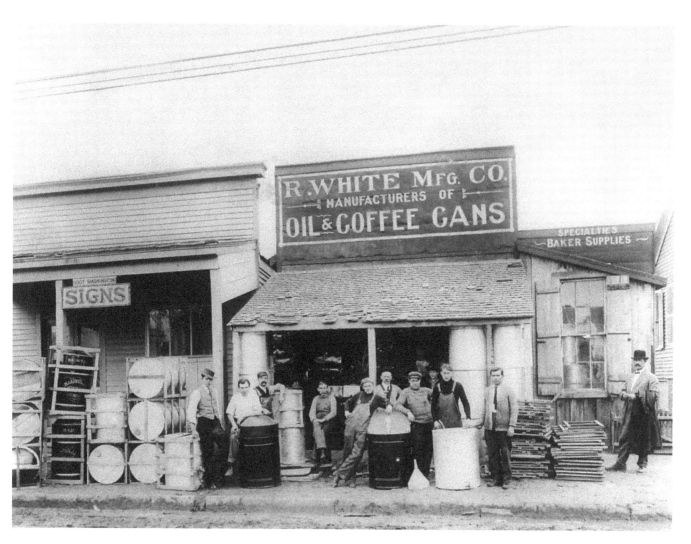

R. White Manufacturing Co., at 1809 Washington Avenue, 1910.

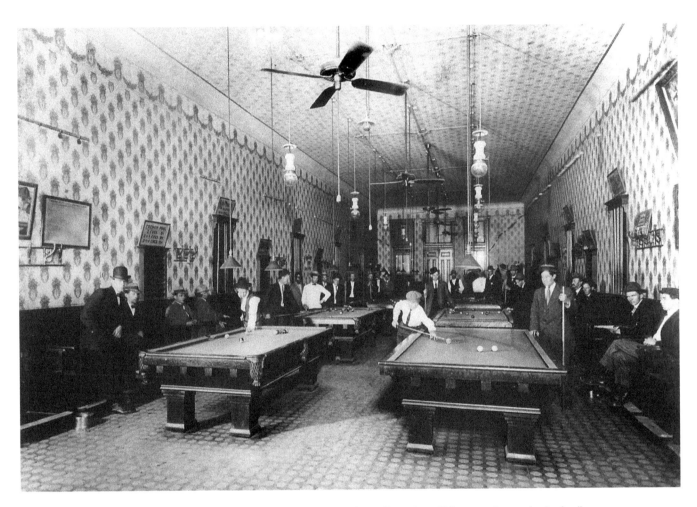

W. Keating Crystal Pool Parlor, 414 Travis Street, 1910. Signs on the wall caution, "If you can't pay, don't play."

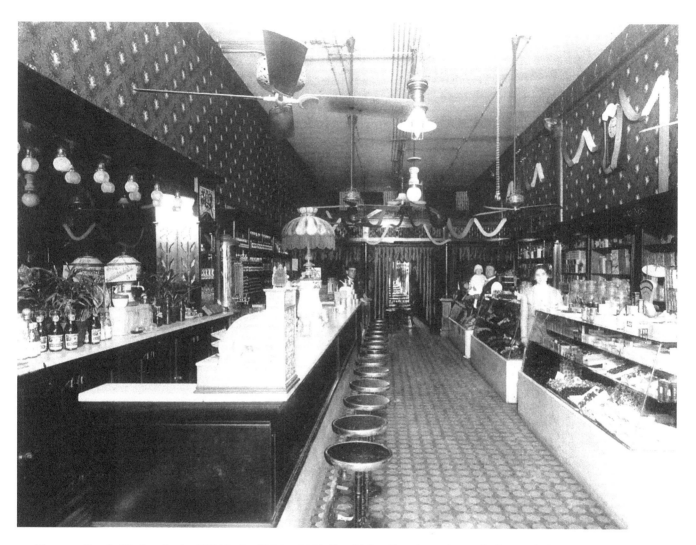

Houston Candy Kitchen in the 700 block of Main, 1911. It sold fine French candies and advertised that it was one of the most up-to-date ice cream parlors in Texas.

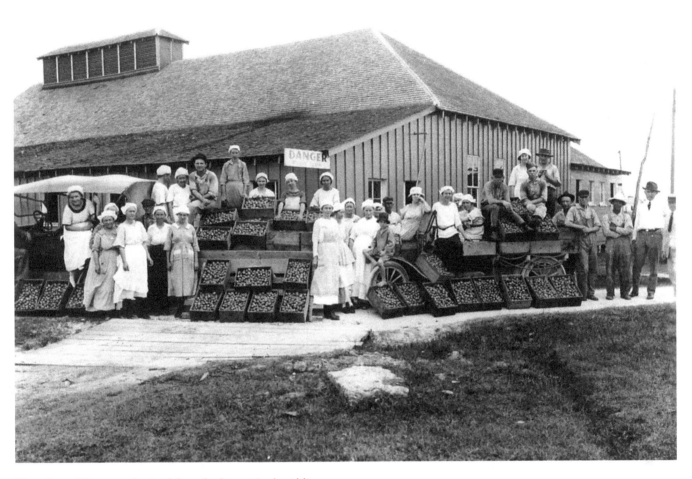

These boxed figs were destined for a fig factory in the Aldine area.

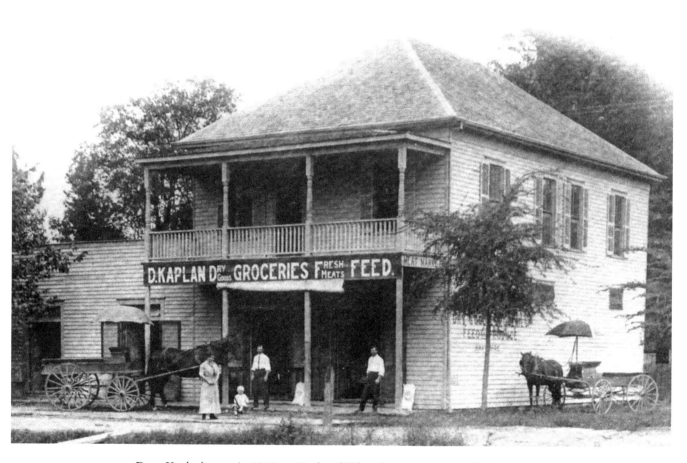

Dave Kaplan's store in 1912 at 22nd and Yale, where its successor, Kaplan's-Ben Hur, operated until 2005.

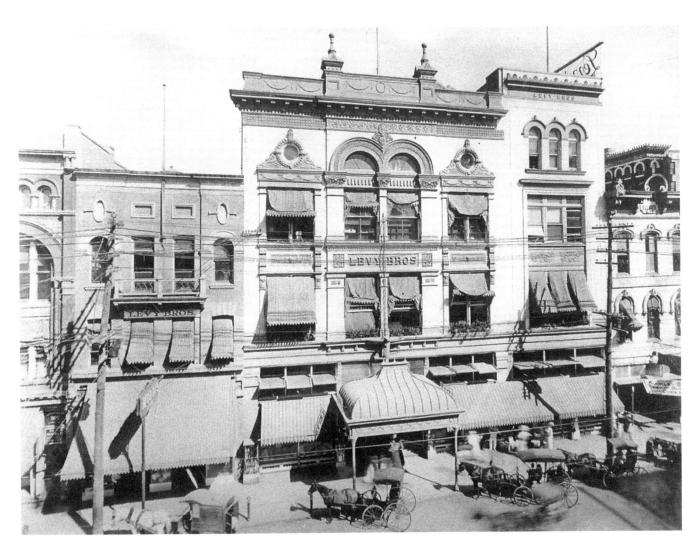

Levy Brothers Dry Goods, founded in 1887 and shown here in 1911.

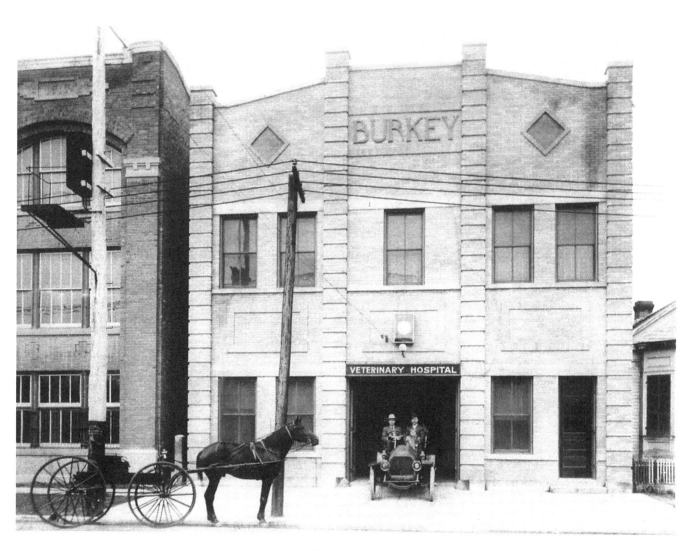

Office and hospital of Drs. Burkey and Burkey, veterinary surgeons, 1910.

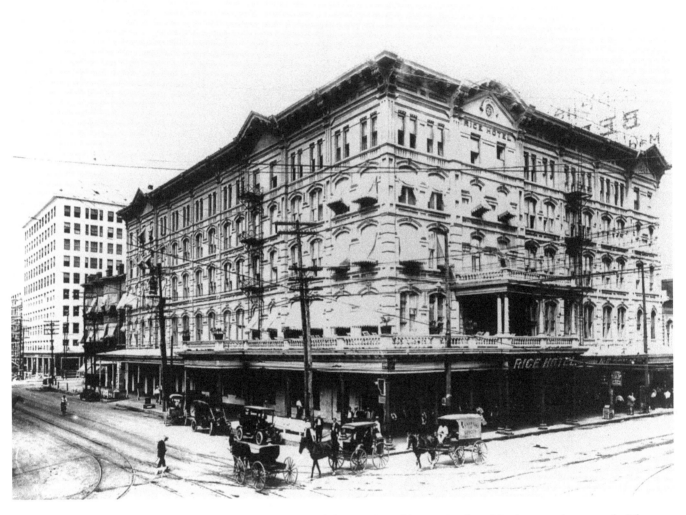

A new Capitol Hotel was built in 1882 and had been renamed the Rice Hotel by 1909, when this photograph was made. The hotel bar had some of the first electric lights in the city.

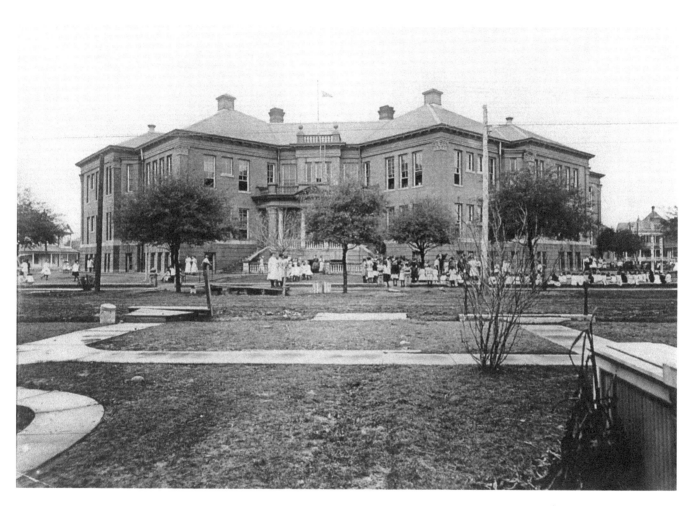

Fannin Elementary School, 1909.

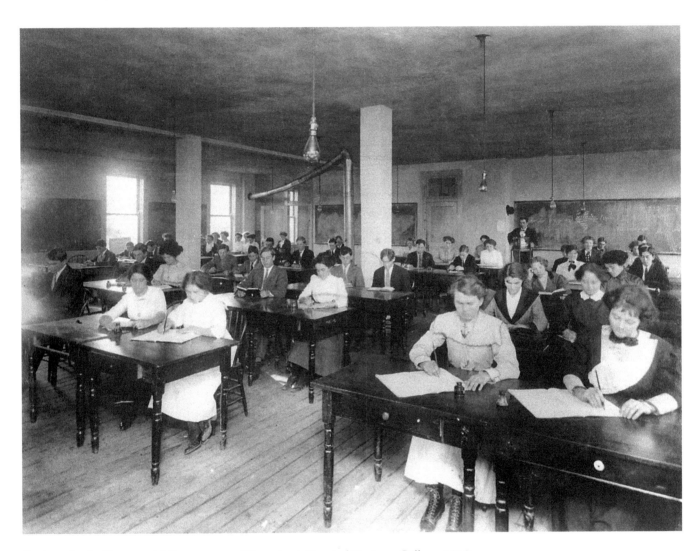

Students in the Commercial Department of Draughon's Practical Business College, 1910.

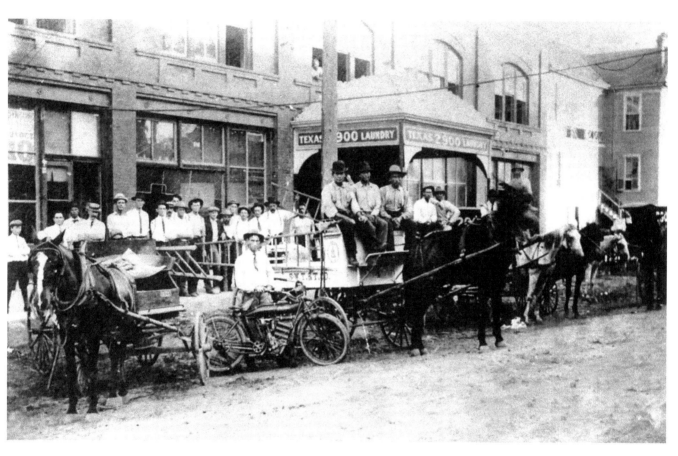

Telephone company employees show off their new motorcycle, circa 1910.

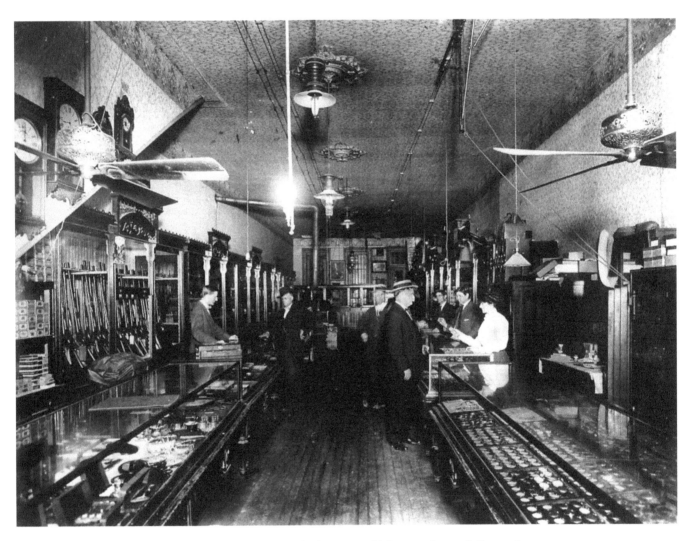

Sweeney Loan Company, at 310 Main Street, in 1910. The business sold fine watches and diamonds, but also advertised as a pawnbroker.

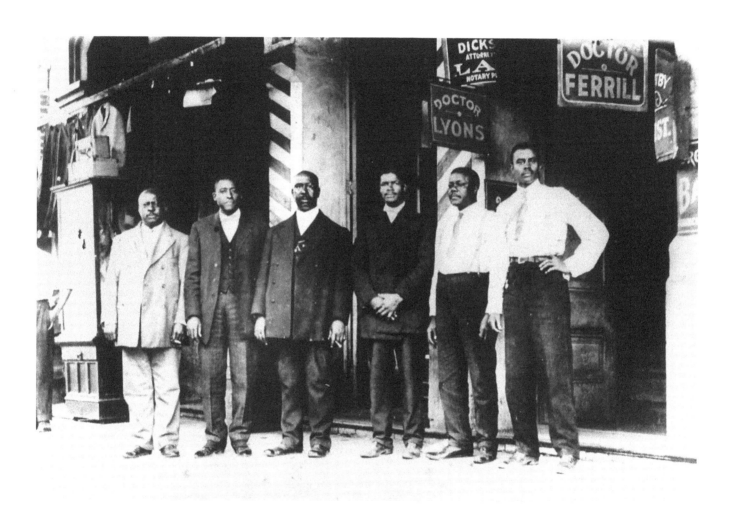

Businessmen pose for a group shot in front of Stafford Harrison's barbershop, at 409 Milam, in 1910.

The Houston Post
Building, 1910. The
newspaper was published
from 1885 until 1995.

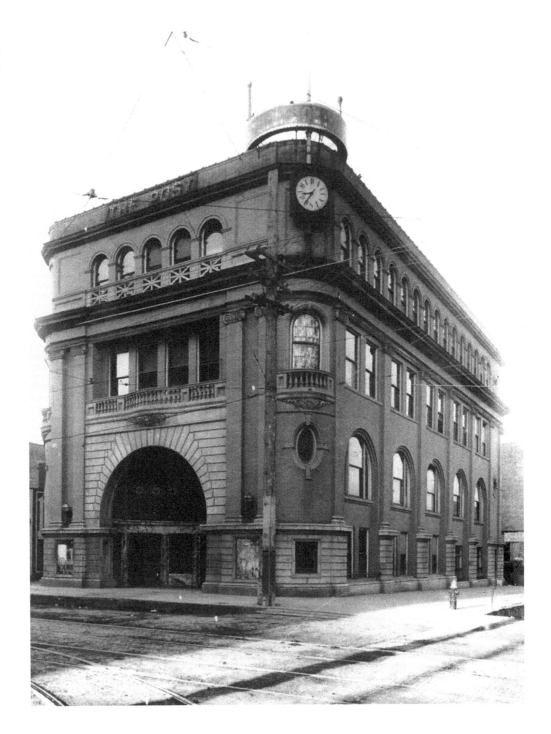

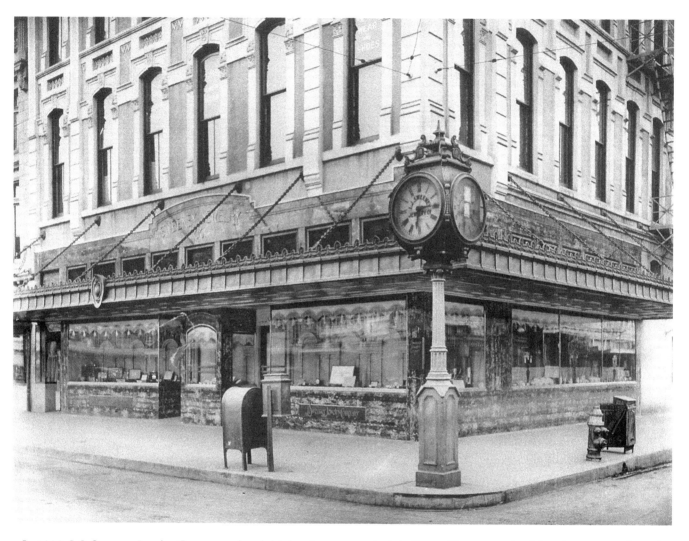

In 1908, J. J. Sweeney Jewelry Company placed this handsome post clock in front of its store at 409 Main Street. It resides today on a special plaza at the intersection of Capitol and Bagby.

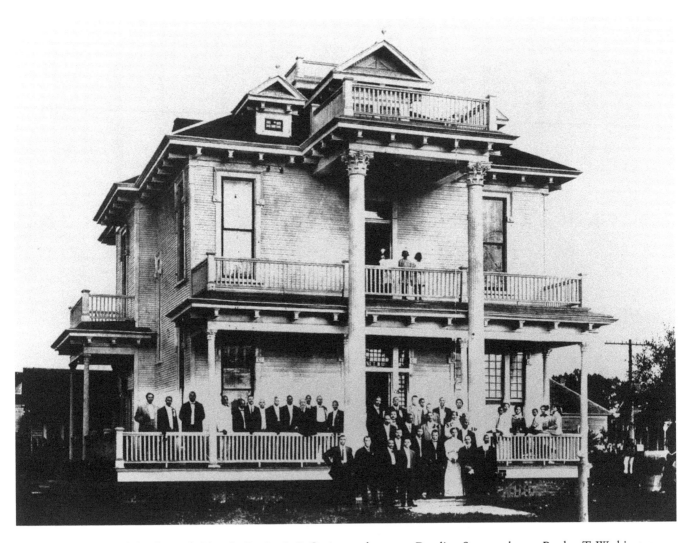

In 1911, guests attended a dinner held at the Benjamin J. Covington home on Dowling Street to honor Booker T. Washington, who visited Houston to encourage organizing a library in the African-American community.

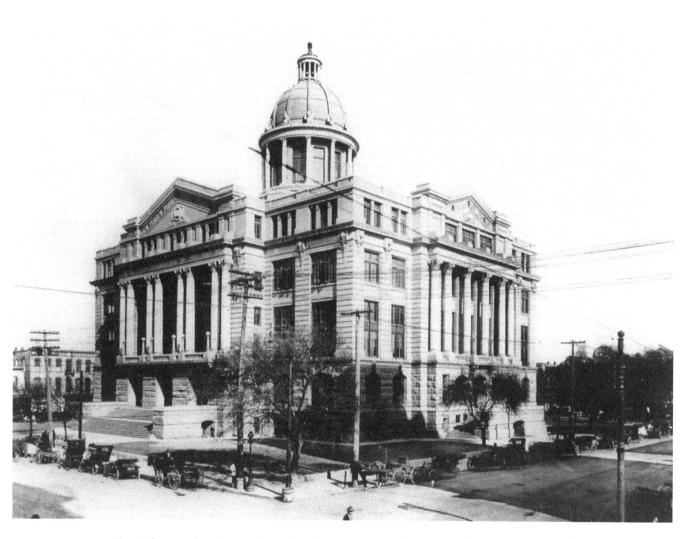

Harris County Courthouse, the fifth building to occupy Courthouse Square, was dedicated on March 2, 1911.

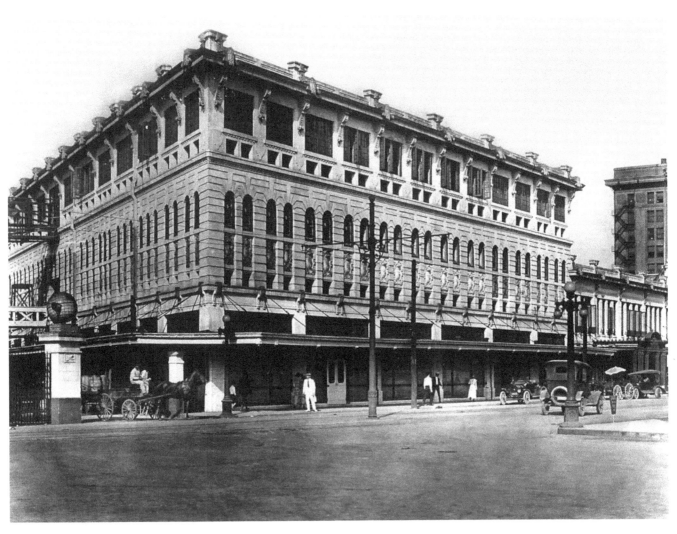

Houston Ice and Brewing Company's massive complex, which spanned both sides of Buffalo Bayou, 1912. The small building on the right, its only surviving structure, has been designated a Protected Landmark by the City of Houston.

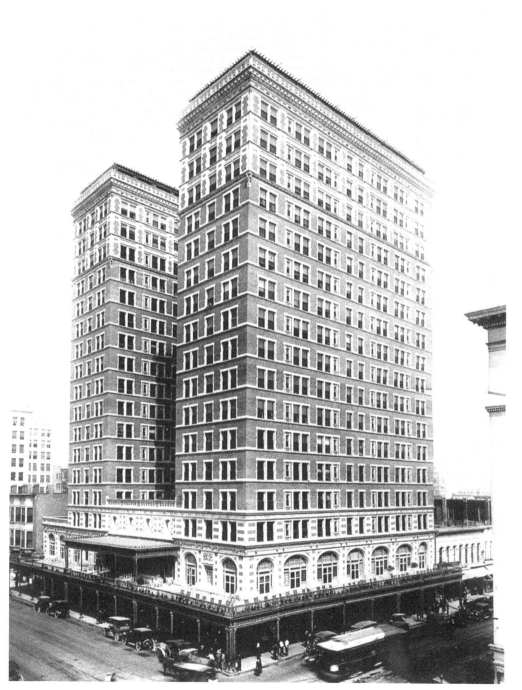

Jesse H. Jones built a new
17-story Rice Hotel, which
opened on May 17, 1913.
The building now houses
residential lofts.

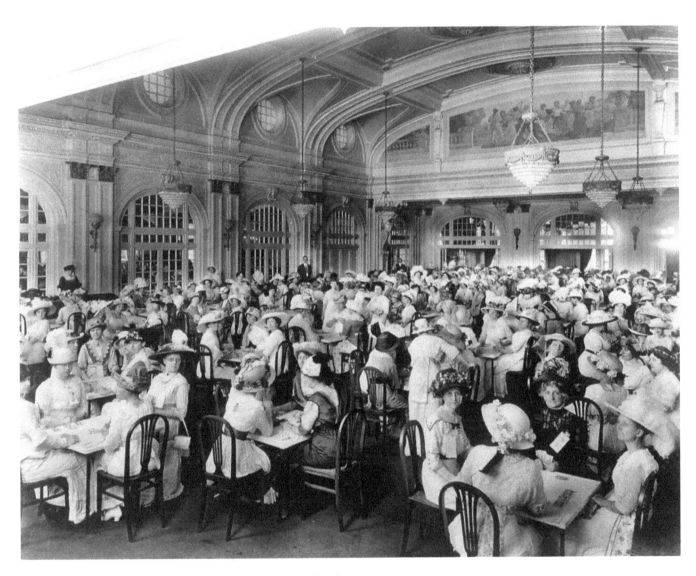

A ladies' bridge party in the Crystal Ballroom of the Rice Hotel, 1913.

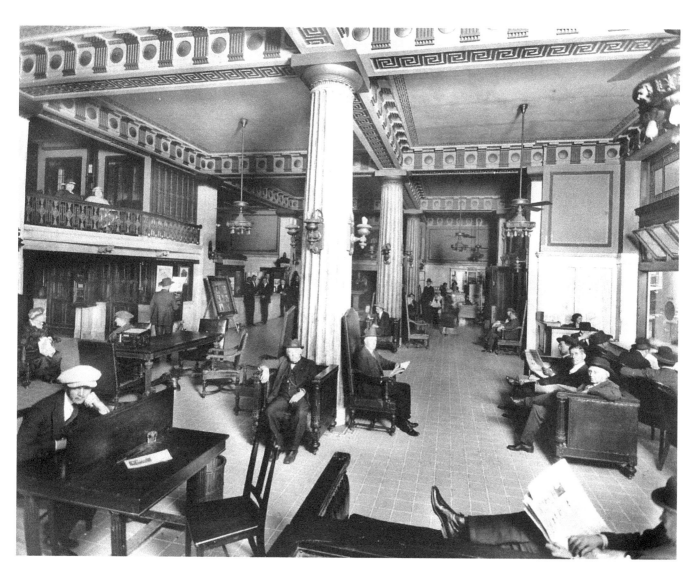

Men relaxing in the Bender Hotel lobby, 1914.

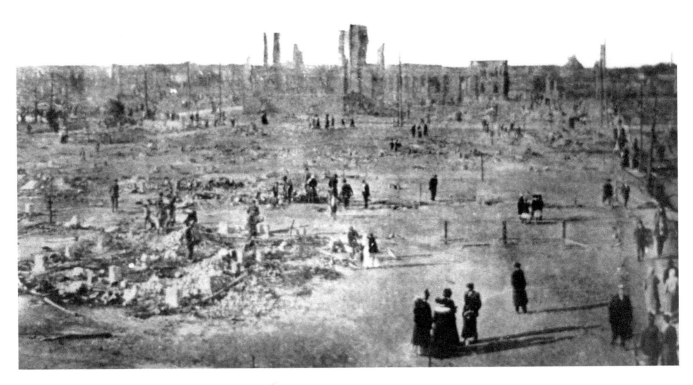

A disastrous fire, fanned by a 38-mile-per-hour wind, destroyed 40 blocks of the Fifth Ward on February 21, 1912.

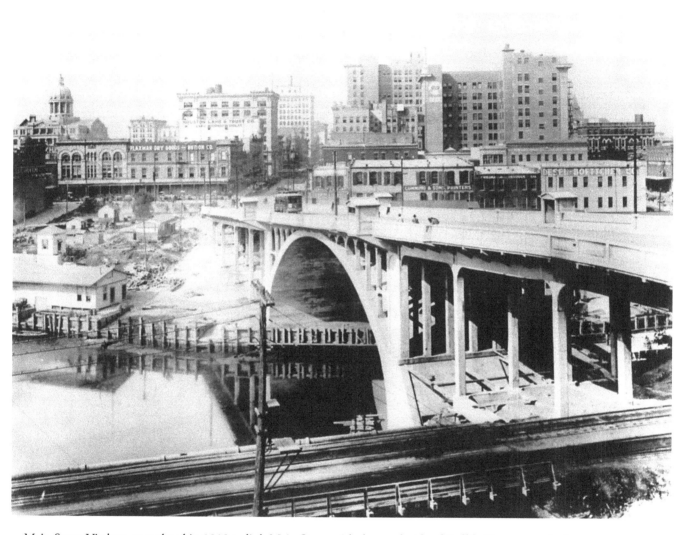

Main Street Viaduct, completed in 1913 to link Main Street with the north side of Buffalo Bayou, was the longest concrete span in Texas at the time.

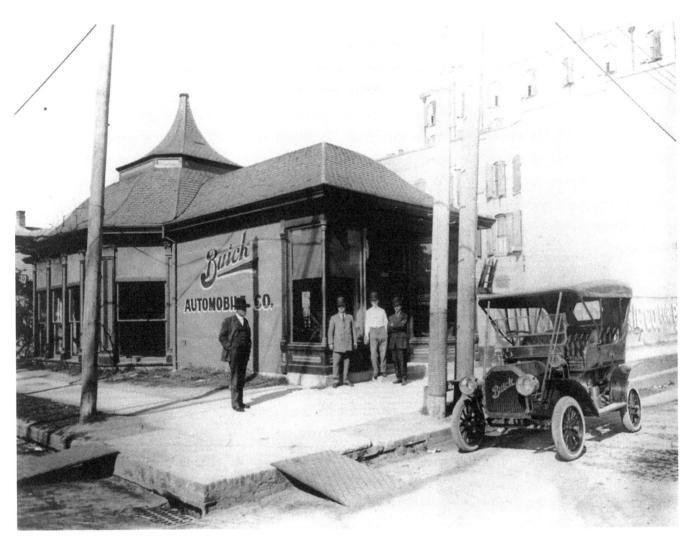

This early automobile dealership was located at 1403 Main Street in 1913 when there were 27 auto companies in the city.

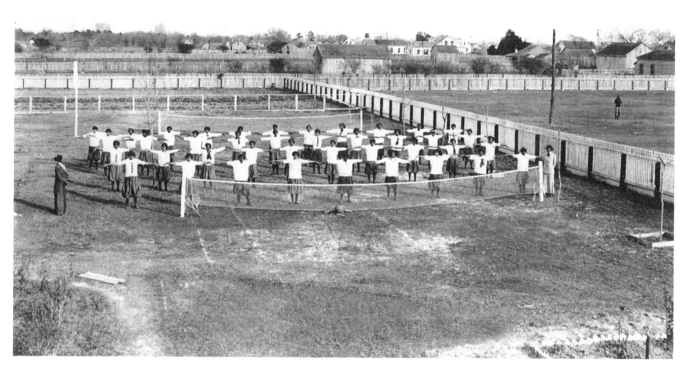

Women's physical education class at Houston College, 1914.

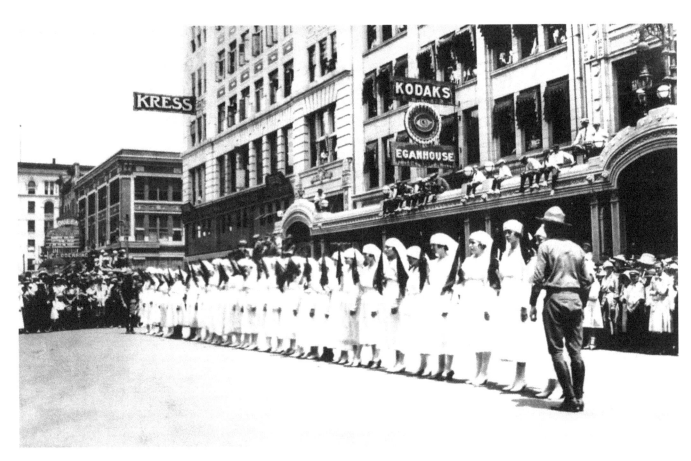

A Red Cross parade, December 16, 1918. Visible in the background are storefronts, among them Kress, a nationwide five-and-dime discount chain popular for decades.

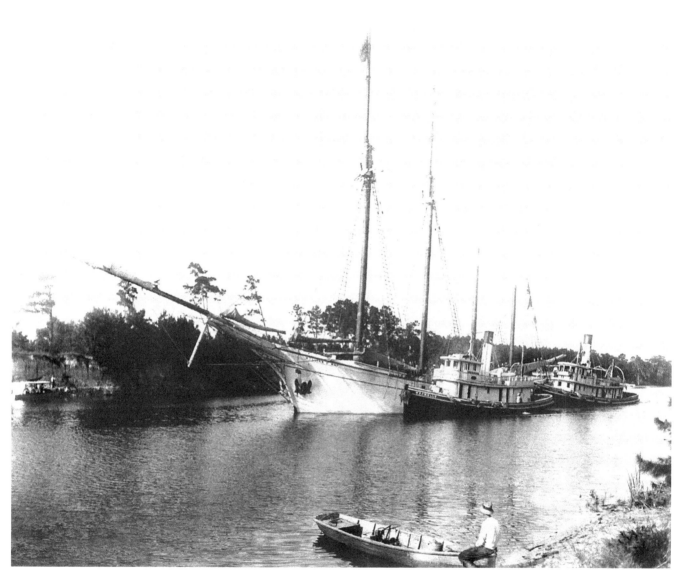

William C. May, the first vessel to arrive at the newly opened Houston Ship Channel, September 26, 1914. The assisting tugboats are the *William J. Kelly* and the *Ima Hogg.*

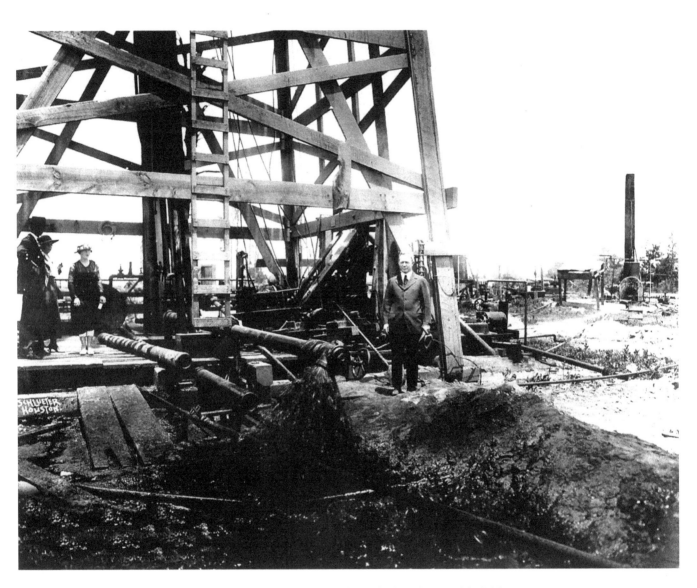

Independent oil producer Henry Staiti and his family inspect his latest find in the Humble field, circa 1915.

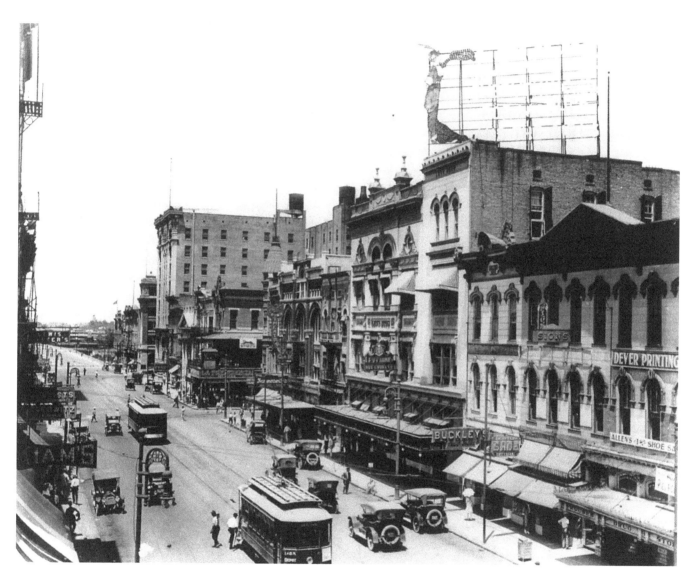

Main Street, facing north from Preston Avenue, 1915.

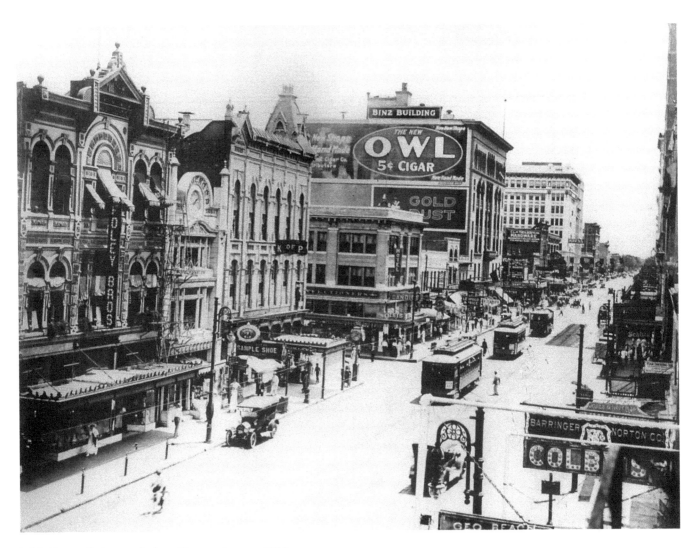

Main Street, facing south from Preston Avenue, 1915.

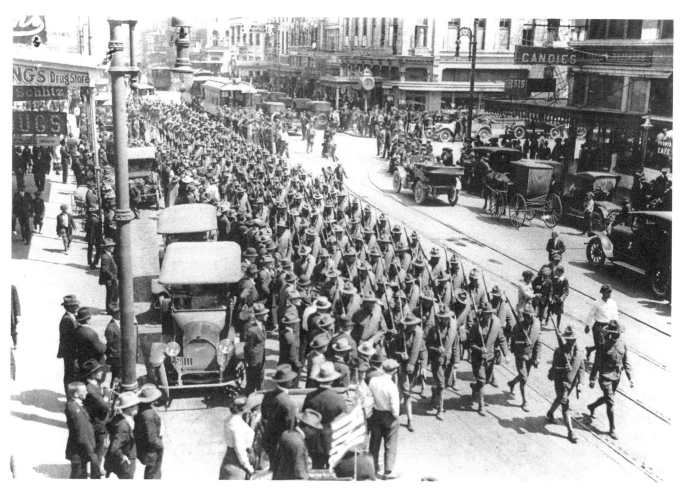

A National Guard unit marches down Main Street in a preparedness parade in 1915.

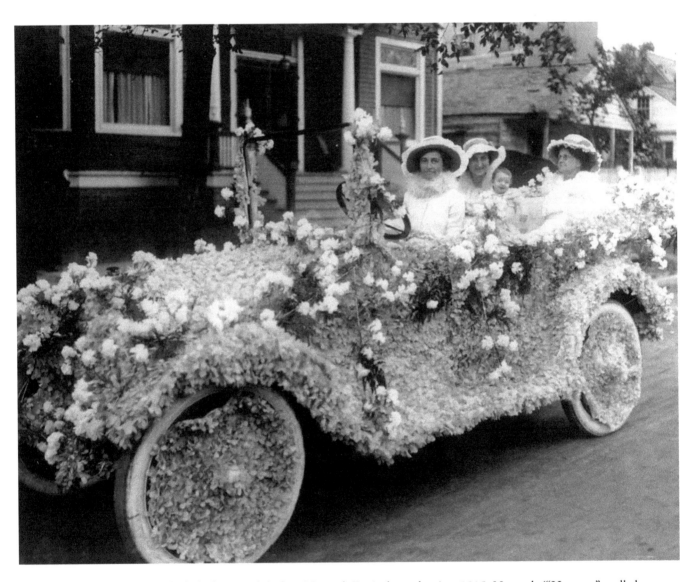

Ferdie Trichelle in her flower-bedecked automobile for a Notsuoh Festival parade, circa 1915. Notsuoh ("Houston" spelled backward) was held annually for almost 20 years to promote the city's commercial advantages.

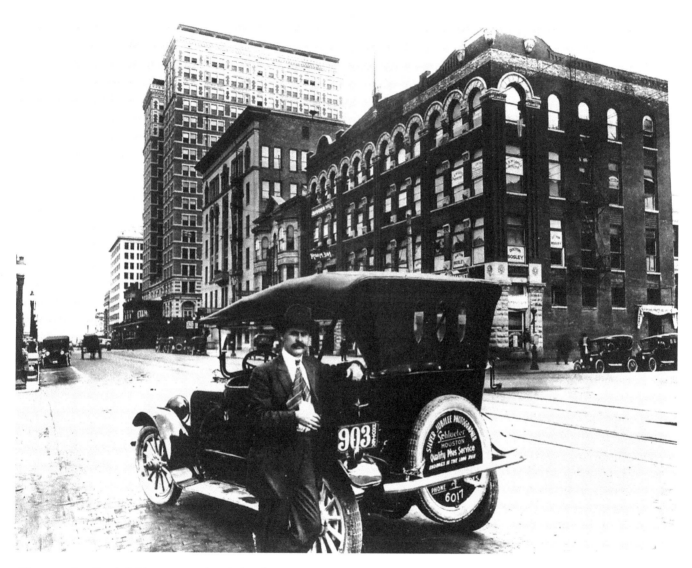

Photographer Frank Schlueter poses beside his shiny, eight-cylinder automobile in 1916 as he advertised his 25th year in business.

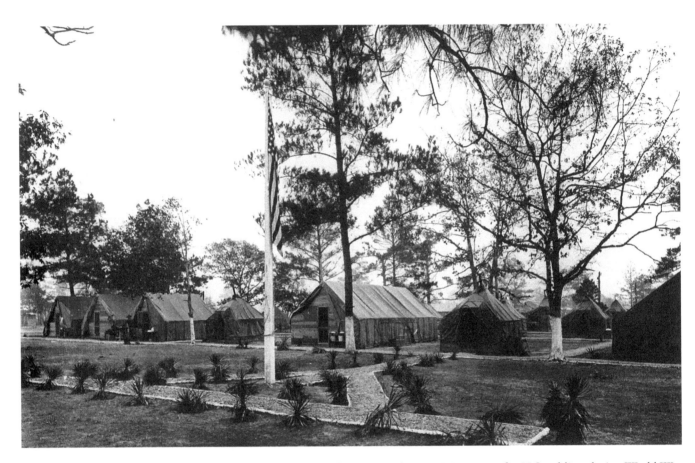

Camp Logan, built on 2,000 acres of land just west of the city limits, served as a training camp for U.S. soldiers during World War I. The property later became Memorial Park, named in honor of the doughboys who fought to defend the nation in the war.

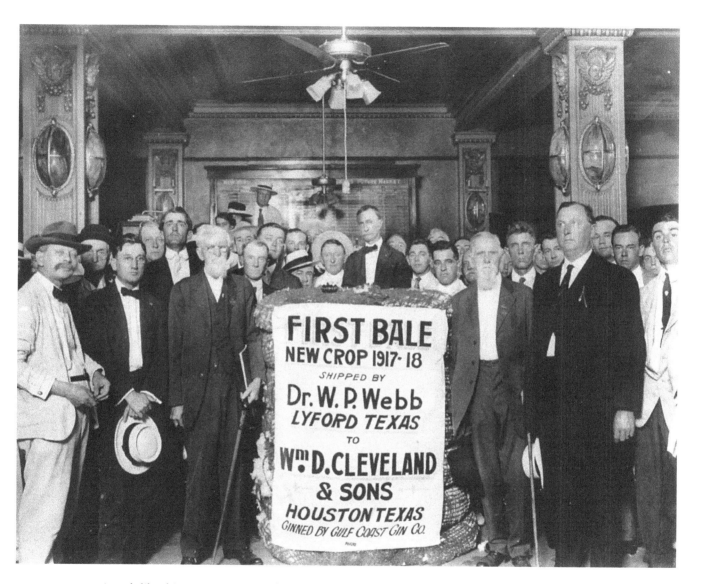

Awards like this one were given to Texas cotton farmers who shipped the first bale of cotton to Houston each year.

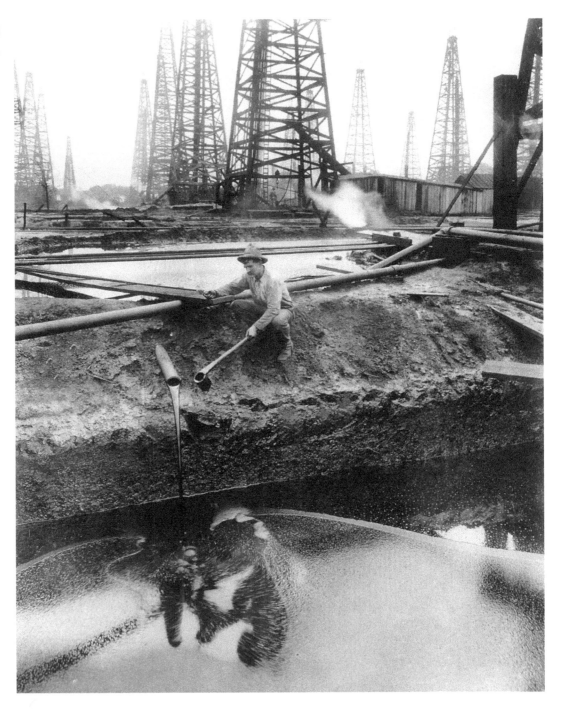

West Columbia oil
field, 1919.

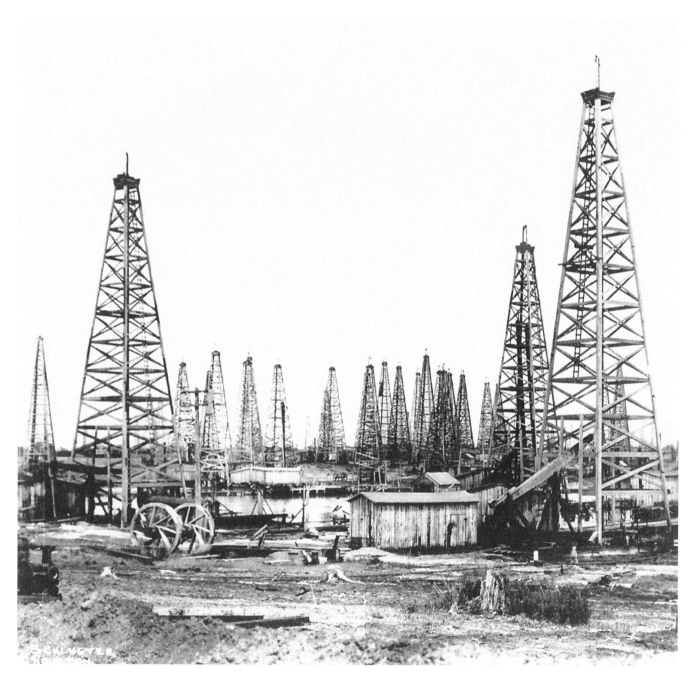

Derricks of the Pierce Junction oil field as seen from downtown Houston, 1918.

The largest single blocks of marble in Texas were used when South Texas Commercial National Bank was built at 215 Main Street.

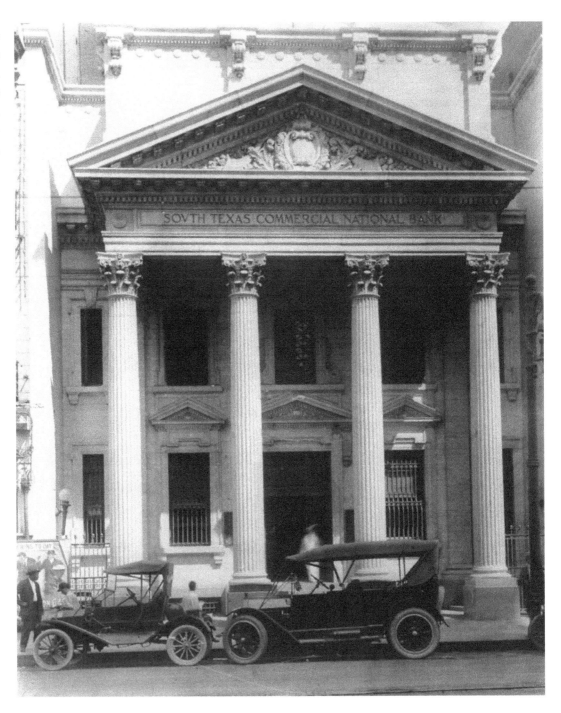

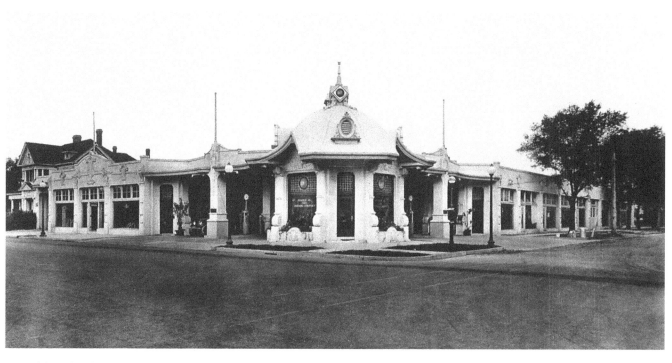

Humble Oil and Refining Company's first filling station at Main and Jefferson, 1919. Designed by Alfred Finn, it boasted elegant features such as mosaic tiles and art glass.

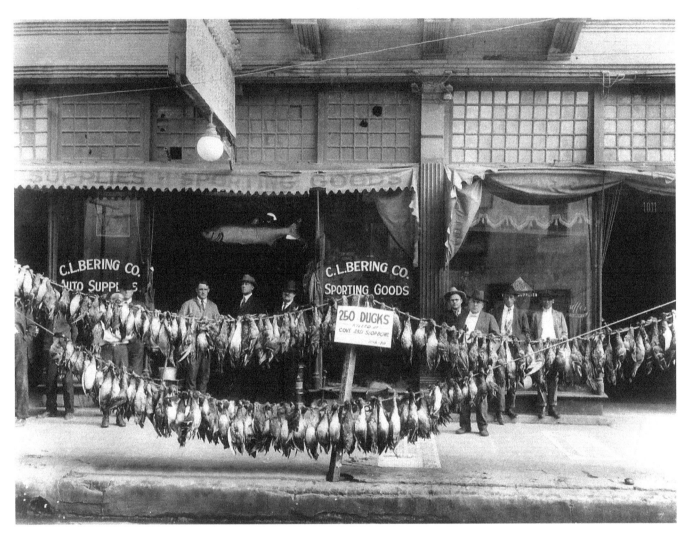

C. L. Bering's promotion of hunting season at his sporting goods store, November 6, 1920.

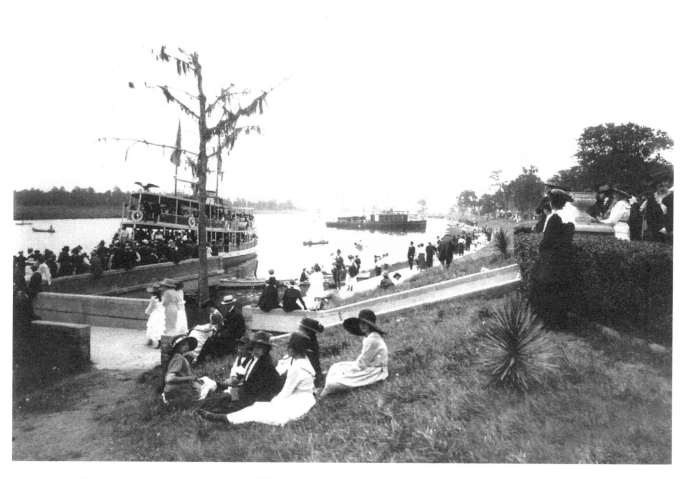

Houstonians arrive by boat for a holiday outing at the San Jacinto Battleground in 1920, where in 1836 General Sam Houston defeated Santa Anna's Mexican forces to pave the way for the Republic of Texas and later entry of Texas into the union as the 28th state.

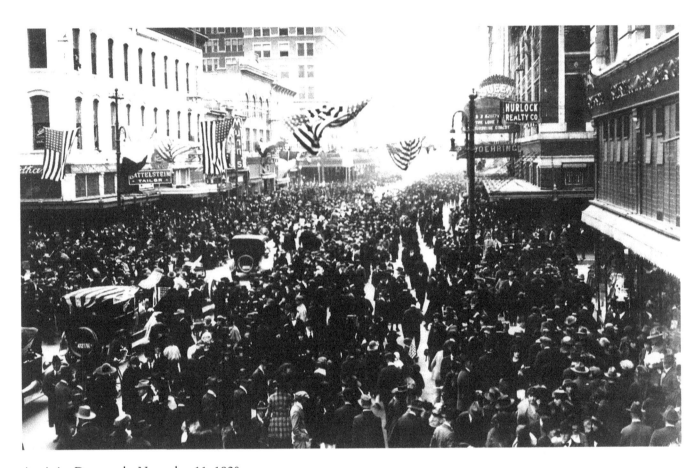

Armistice Day parade, November 11, 1920.

HOUSTON ON THE MOVE

(1921–1970s)

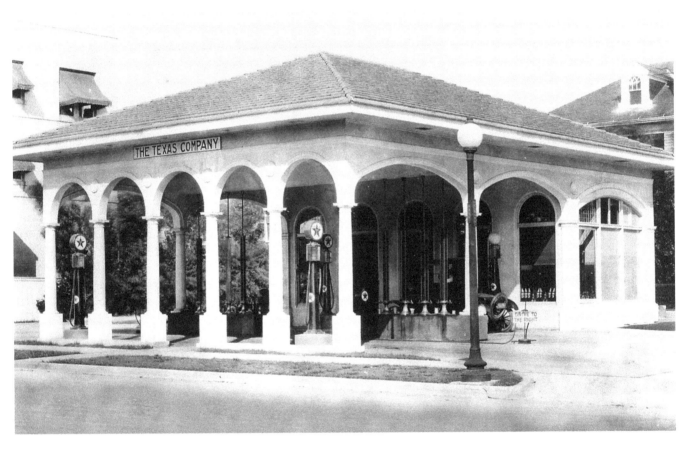

Texas Company (Texaco) station, Main at Bremond, 1922.

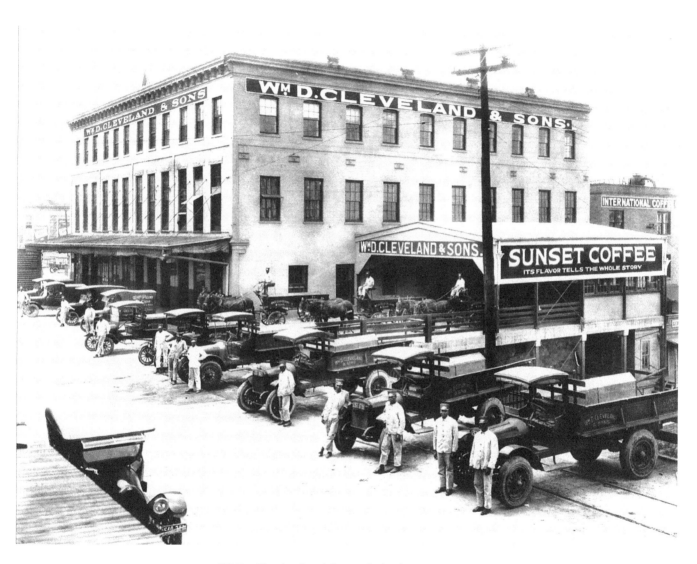

W. D. Cleveland and Sons, wholesale grocery company on Commerce near Buffalo Bayou.

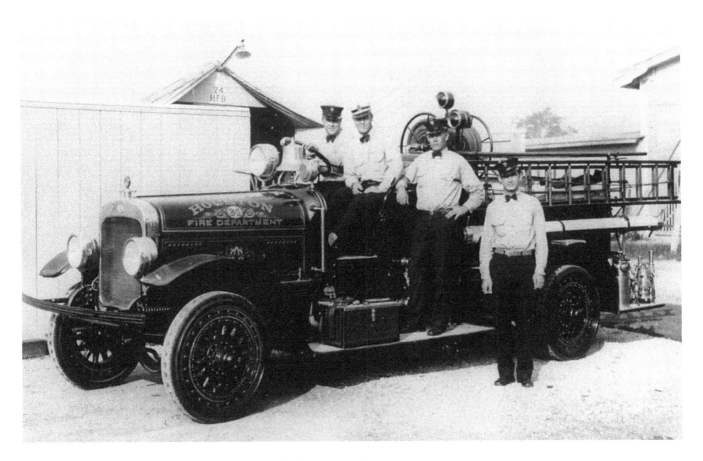

Houston Fire Department Engine Company no. 24 and its tent station, 1924.

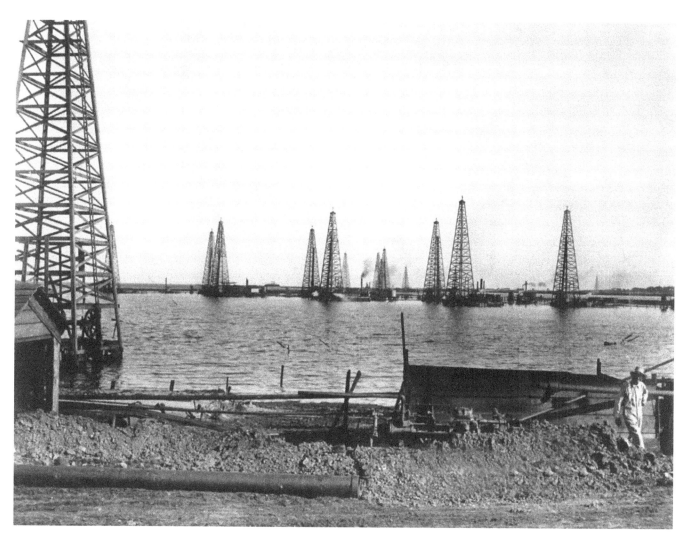

Goose Creek oil field, site of the first offshore drilling along the Gulf Coast, 1923.

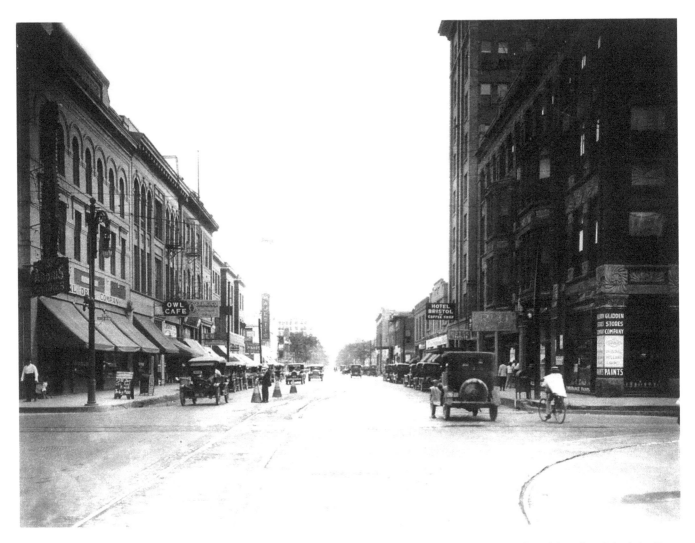

Travis Avenue, looking north from Rusk, circa 1925. The Bristol Hotel, built in 1908 as Houston's first deluxe hotel, had the first roof garden in Texas.

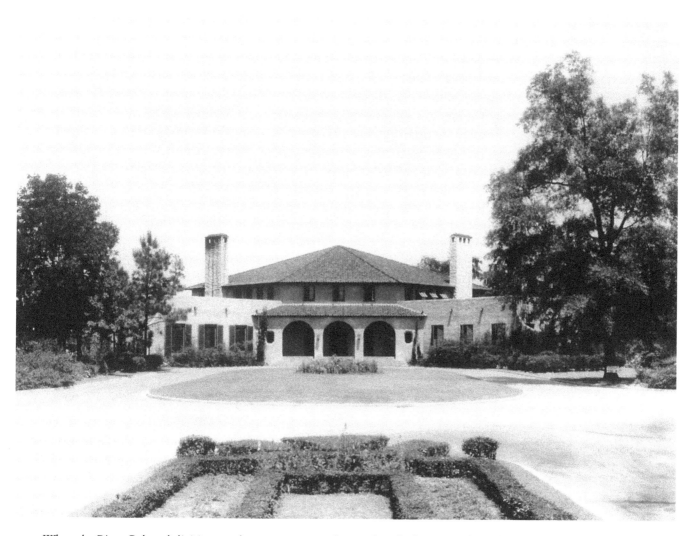

When the River Oaks subdivision was begun, everyone who purchased a lot received membership in the River Oaks Country Club. This 1924 building, designed by John Staub, was replaced with the present one in 1969.

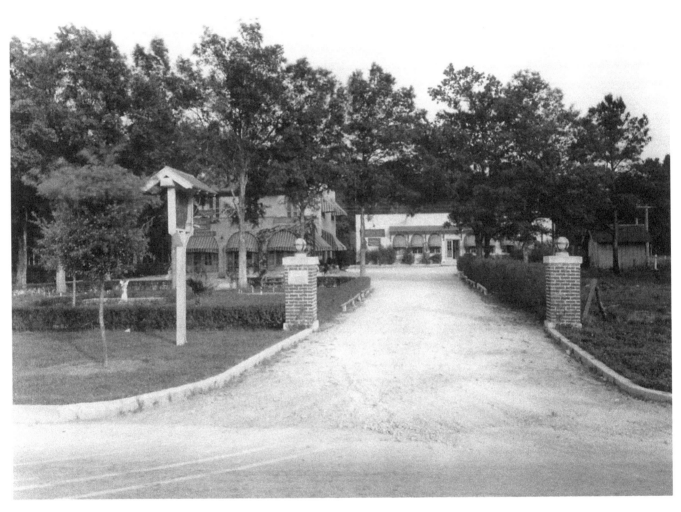

Ye Olde College Inn, seen here in 1924, received accolades in the 1950s as "one of the 20 greatest restaurants of the world."

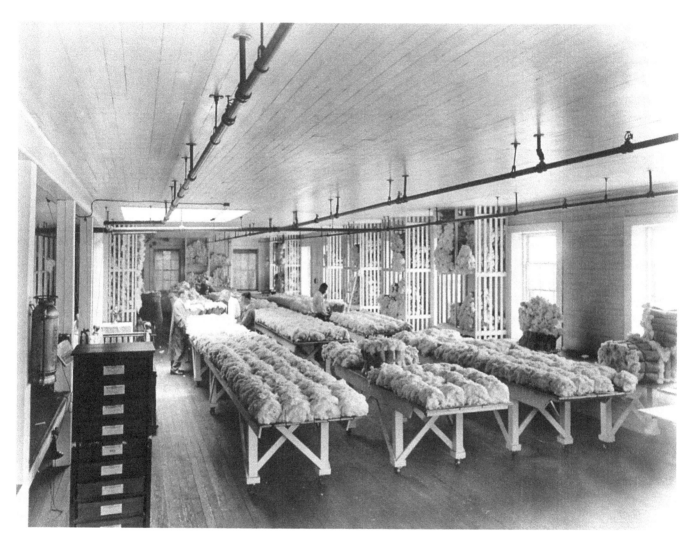

Cotton examiners determine the grade of cotton in the new Cotton Exchange Building on Prairie Avenue, 1924.

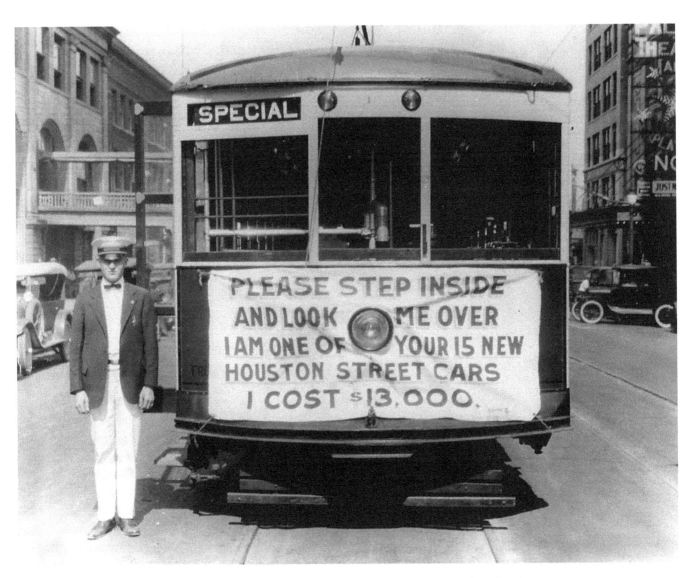

The Houston Electric Company promotes its services by inviting Houstonians to step on board and inspect a new streetcar, September 4-5, 1924.

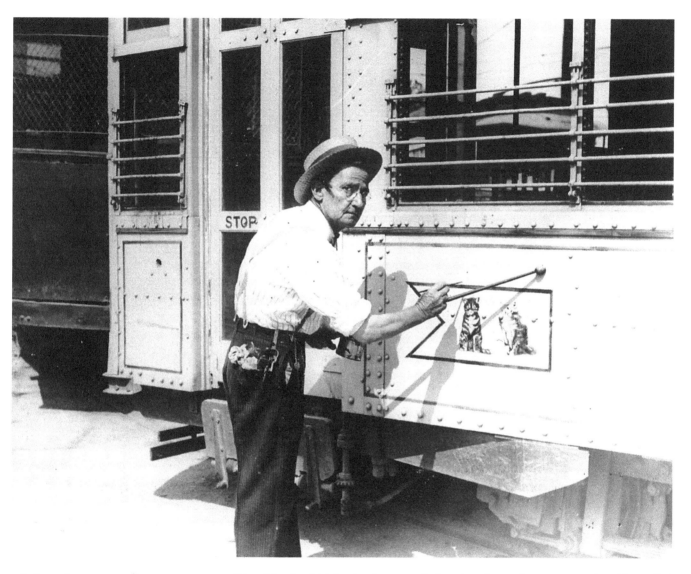

A sign painter personalizes a streetcar, possibly with a local high school mascot. Before the advent of computers, advertising relied on the hard-won skills of these talented artisans.

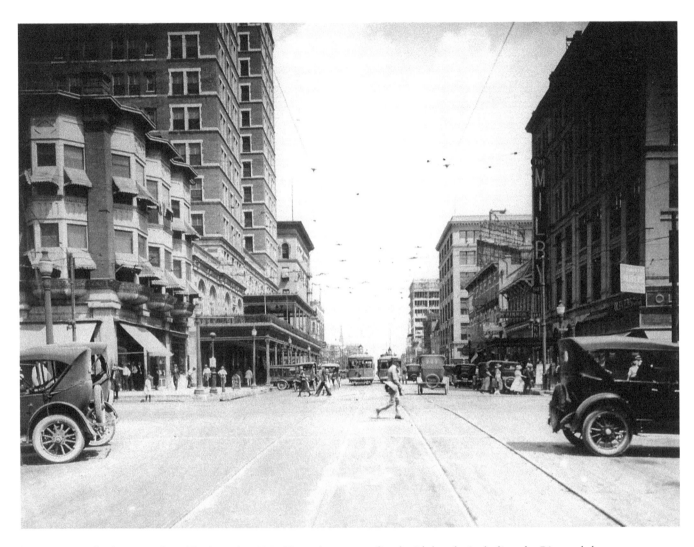

Texas Avenue, looking east from Travis, early 1920s. Texas Avenue was lined with hotels, including the Rice and the Milby seen here.

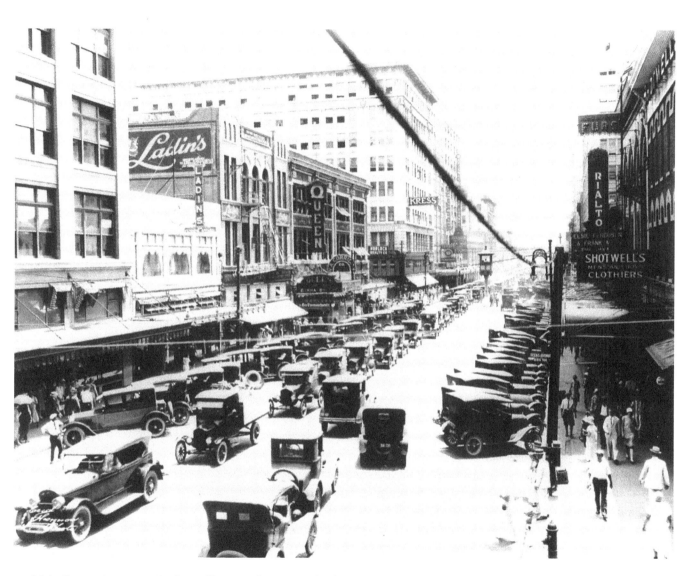

Main Street, circa 1925. In the traffic control tower in the distance, a policeman was needed to flip switches that controlled the lights at several intersections.

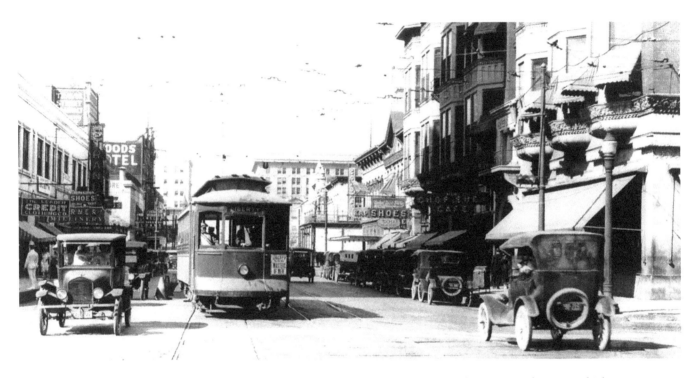

Travis Street, facing north from Texas Avenue, mid-1920s. The building on the right is the Rice Hotel Annex, which was demolished soon thereafter to build the hotel's third wing.

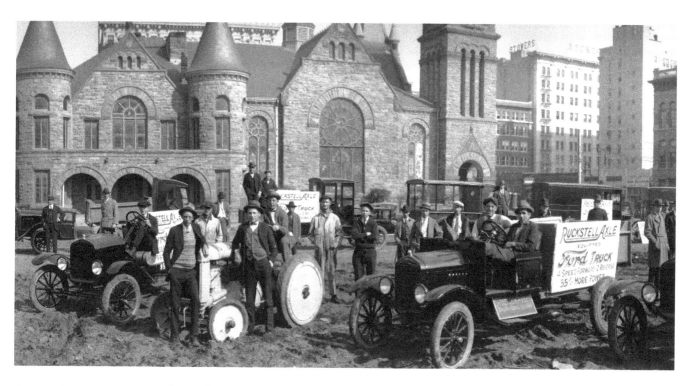

Automotive event promoting the Ruckstell Axle, January 14, 1925. The Houston Public Library and First Presbyterian Church are visible in the background.

Sculptor Enrico Cerrachio's statue of Sam Houston is installed in Hermann Park in 1925.

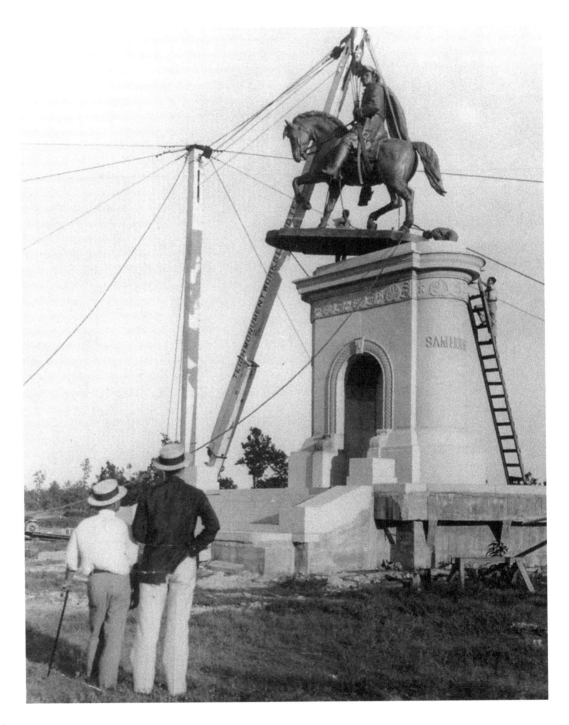

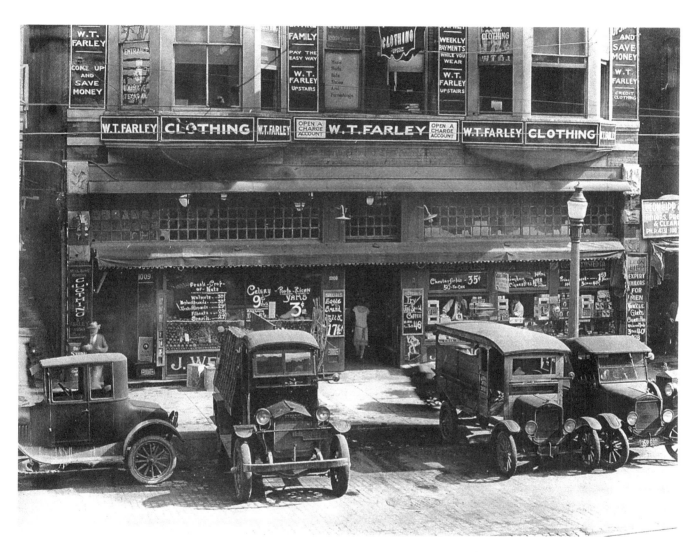

Weingarten's Grocery Store on Texas Avenue, 1925.

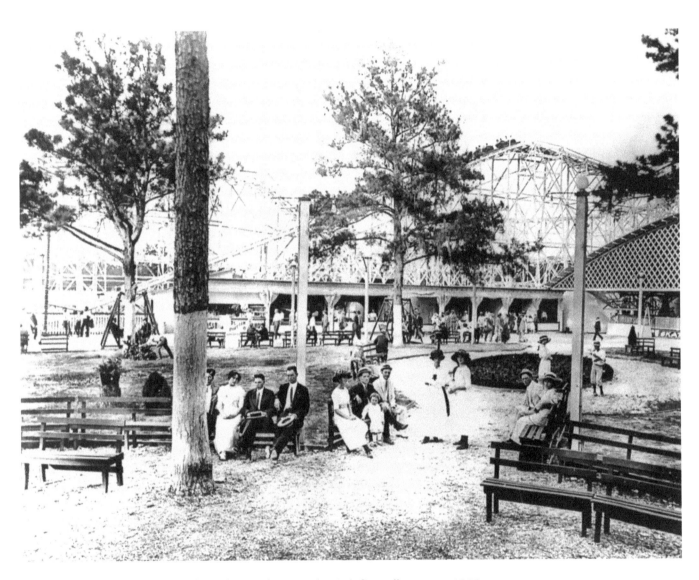

Luna Park, located near Woodland Heights, was home to the city's first roller coaster, 1925.

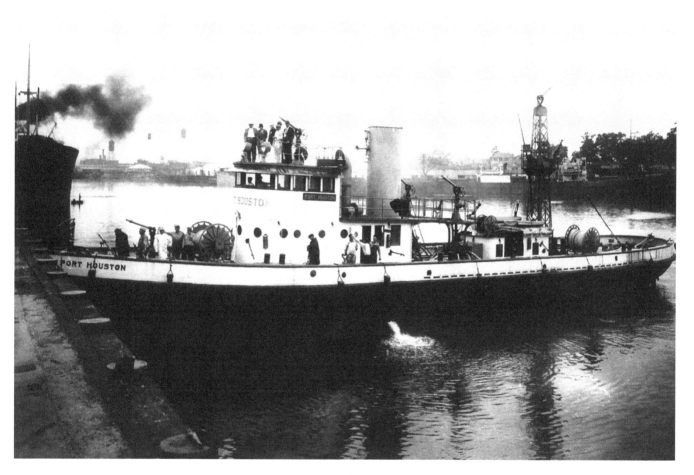

Port Houston, the first boat used on the Houston Ship Channel to fight fires, 1926.

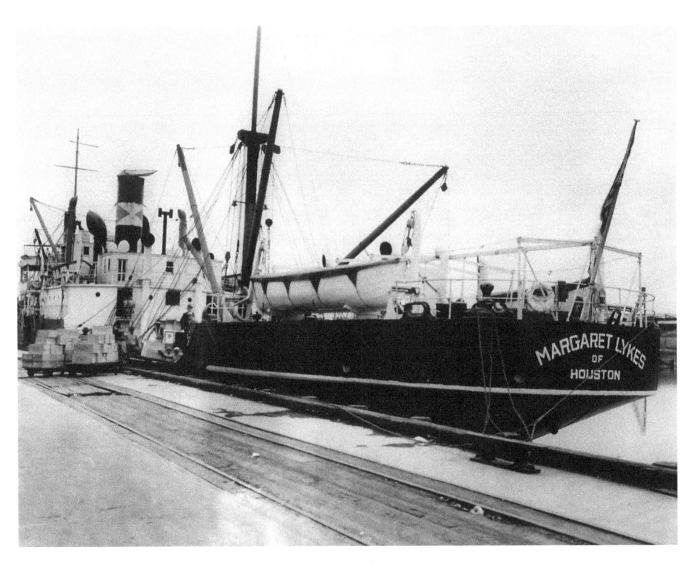

The *Margaret Lykes* lies docked at the Port of Houston for loading in the 1920s.

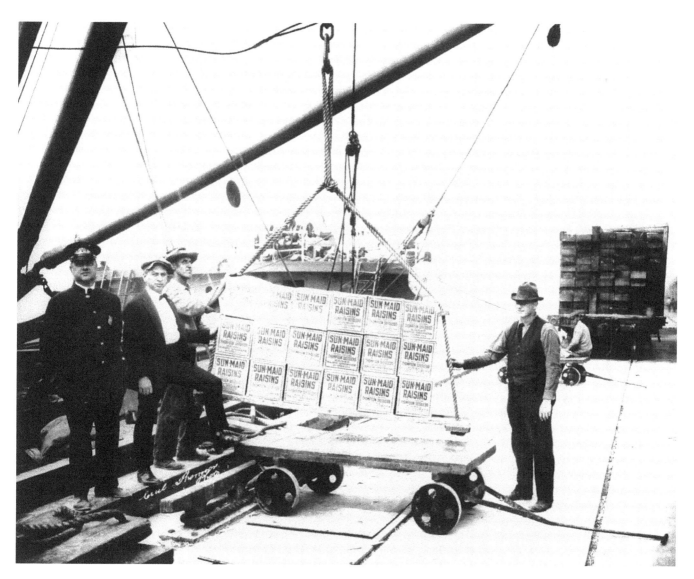

Cargo is unloaded at the Port of Houston.

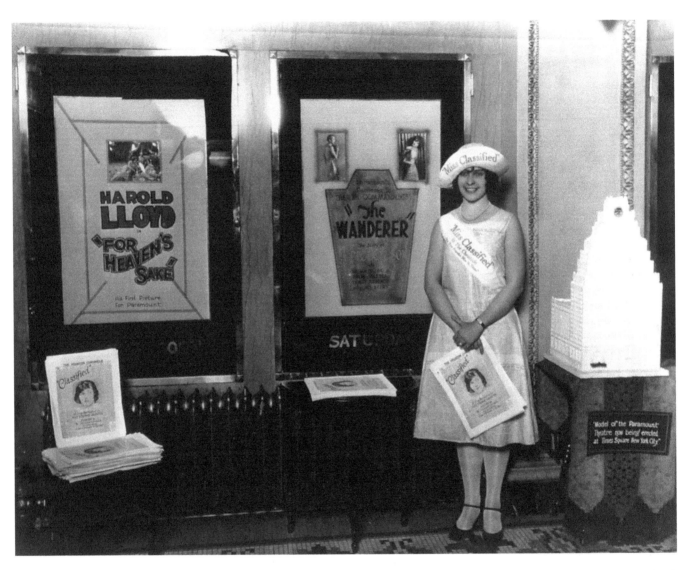

The *Houston Chronicle*'s Miss Classified, dubbed the Most Popular Miss in Texas, poses for the camera at a promotional event held in the Isis Theatre in 1927.

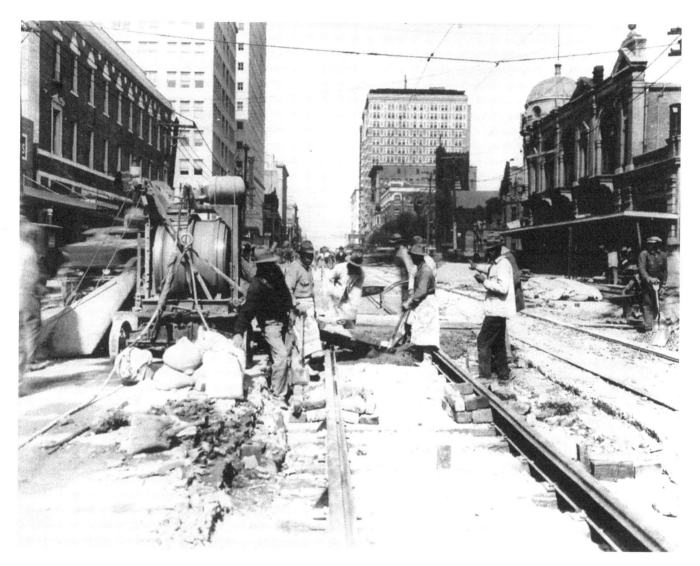

Workers replace the asphalt surface of Texas Avenue with concrete.

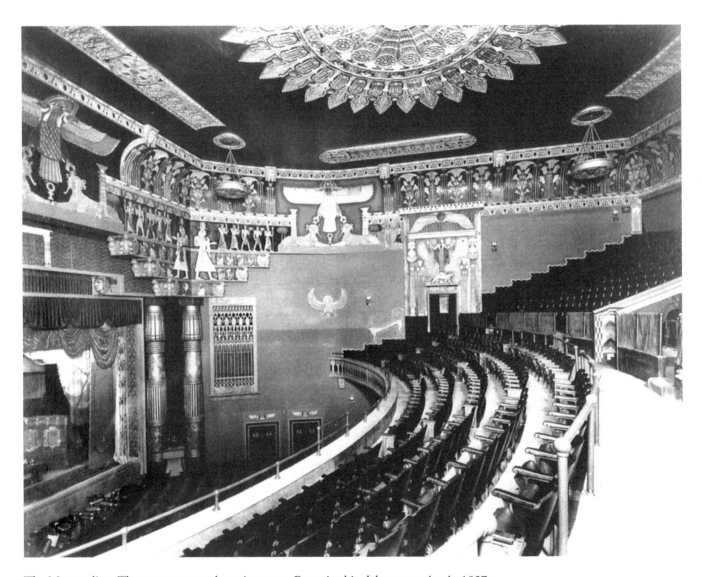

The Metropolitan Theatre transported moviegoers to Egypt in this elaborate setting in 1927.

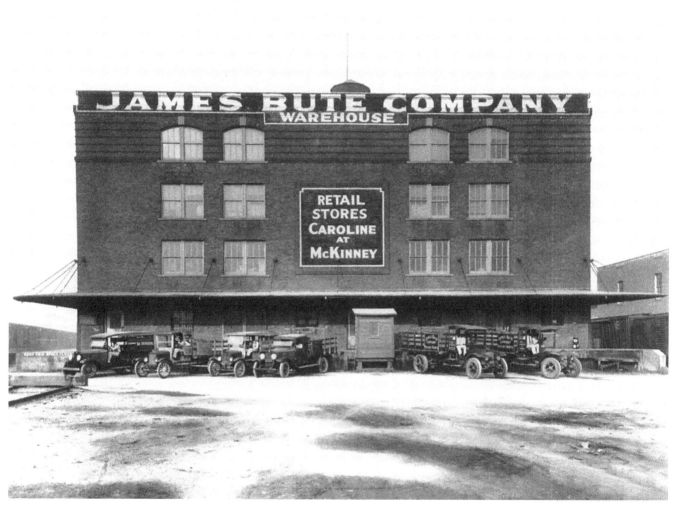

James Bute Paint Company warehouse, 1926. The building now houses Dakota Lofts, a downtown residential property.

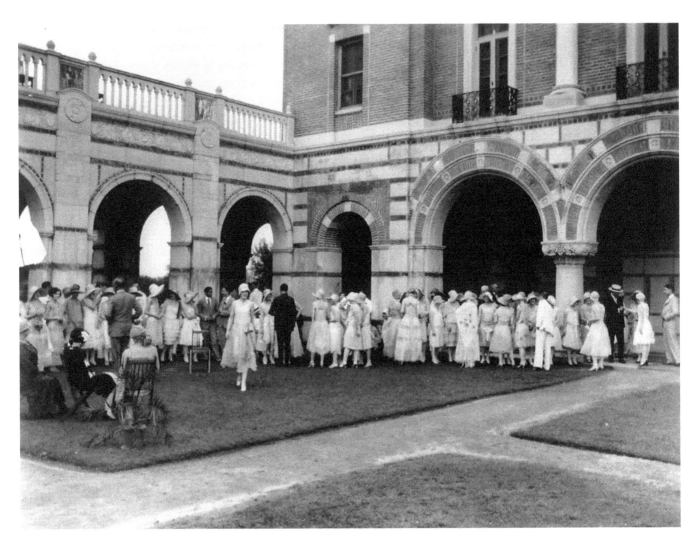

Graduation Day at Rice Institute (now Rice University), June 6, 1927.

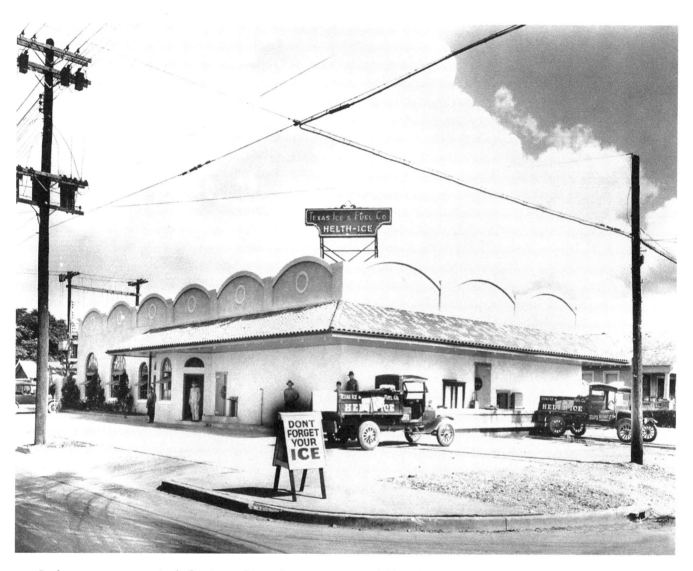

Ice houses were a necessity before ice-making refrigeration was available in homes. Texas Ice and Fuel Company was located at 6301 Harrisburg Boulevard.

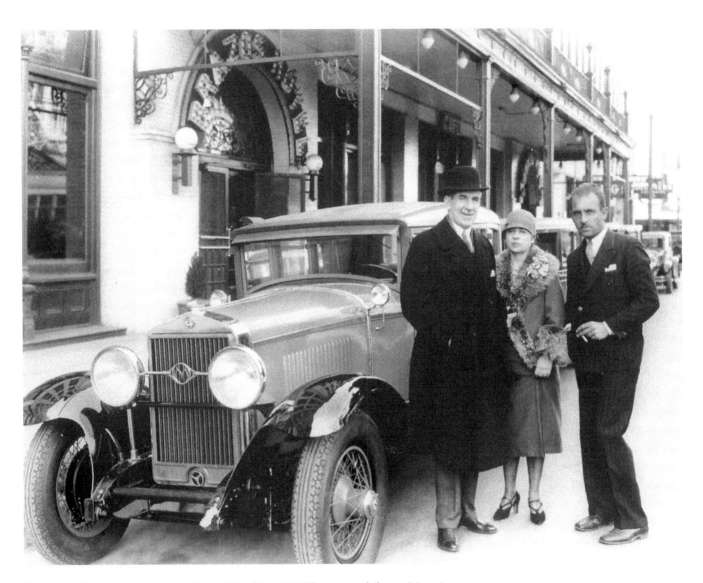

Visitors to Houston arrive at the Brazos Hotel in 1928. The automobile is a Marmion.

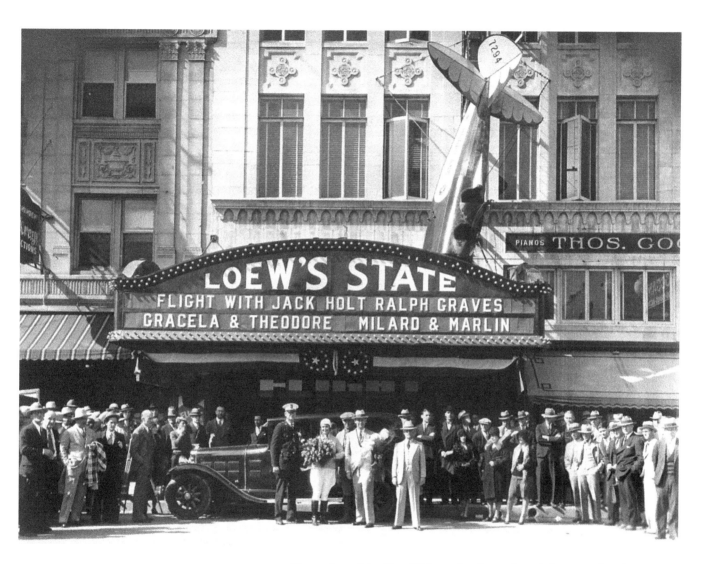

Promotion of the film *Flight,* at the elegant Loew's State movie palace, 1929.

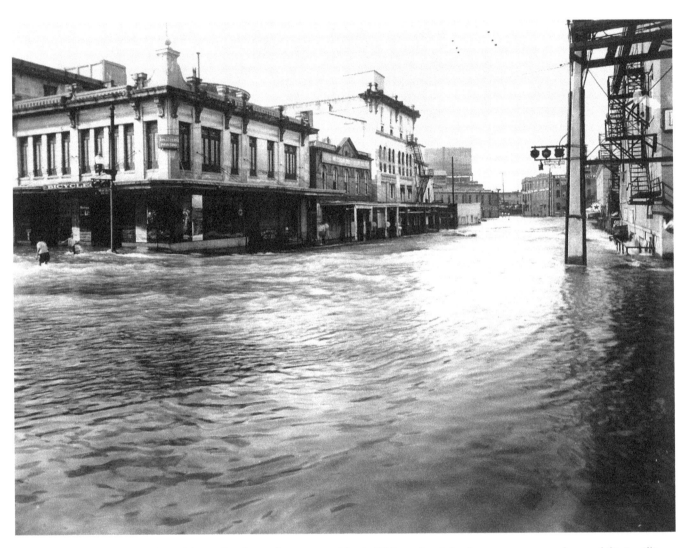

Floodwaters at the corner of Franklin and Milam, after a torrential rainfall inundated the downtown area and caused $1.5 million in damages, May 1929.

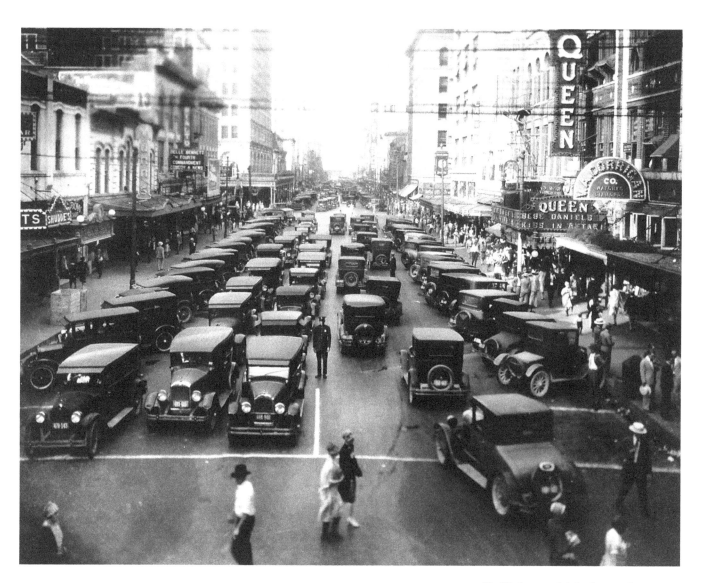

Traffic jam on Main Street, circa 1930.

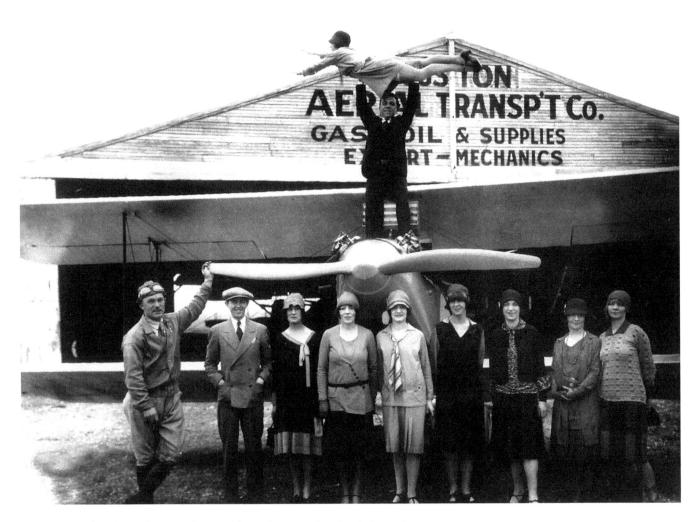

Companies often devised eye-catching publicity shots to advertise their services.

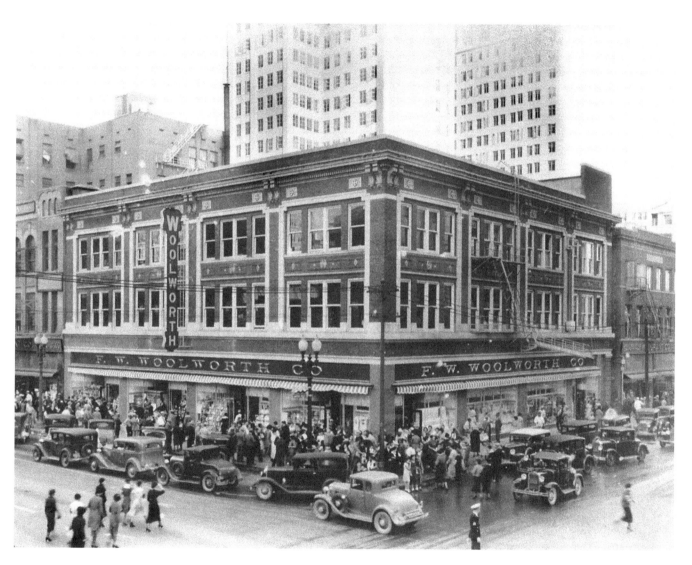

Shoppers hustle and bustle around F. W. Woolworth Company at the corner of Main and Capitol in 1935.

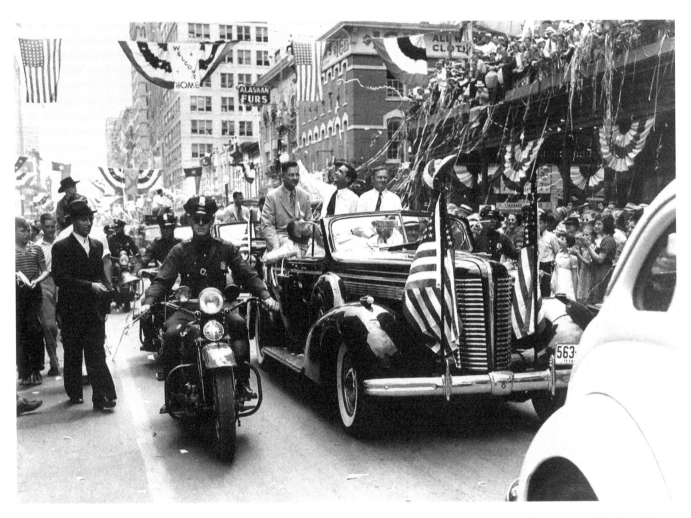

After setting a round-the-world flight record, Howard Hughes, Jr., returned to his hometown for a ticker tape parade viewed by 250,000 spectators, July 30, 1938.

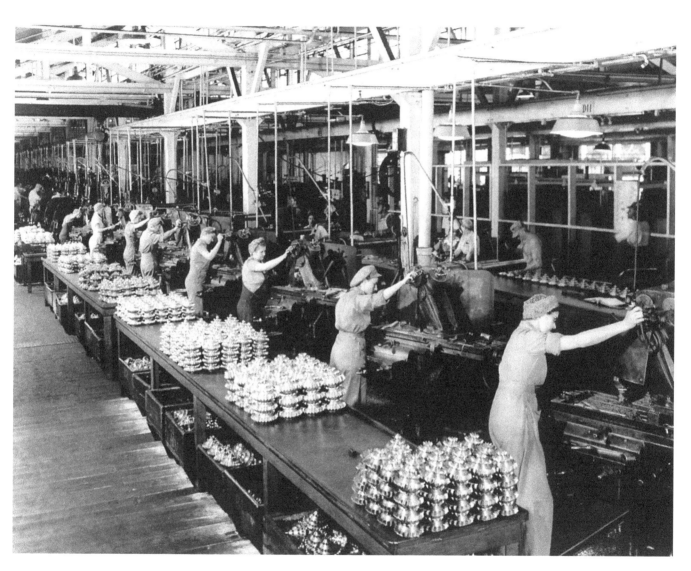

Women employees of Hughes Tool Company machine cones for drill bits during World War II.

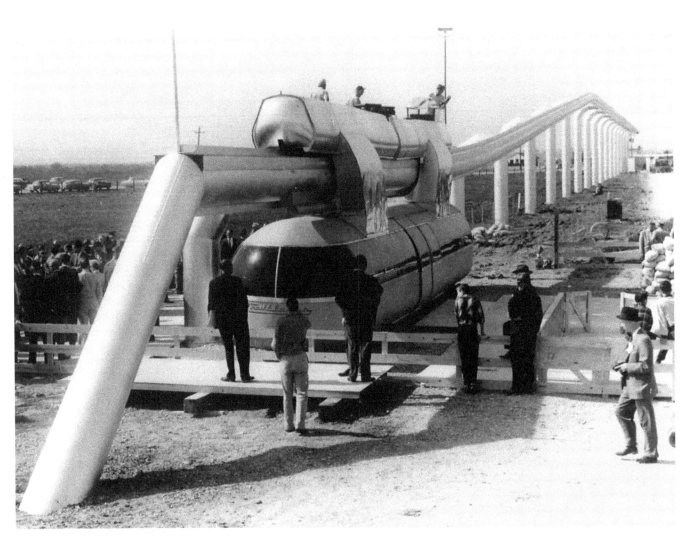

Trailblazer Monorail on opening day in Arrowhead Park, February 18, 1955. The transit experiment did not prove successful and was soon abandoned.

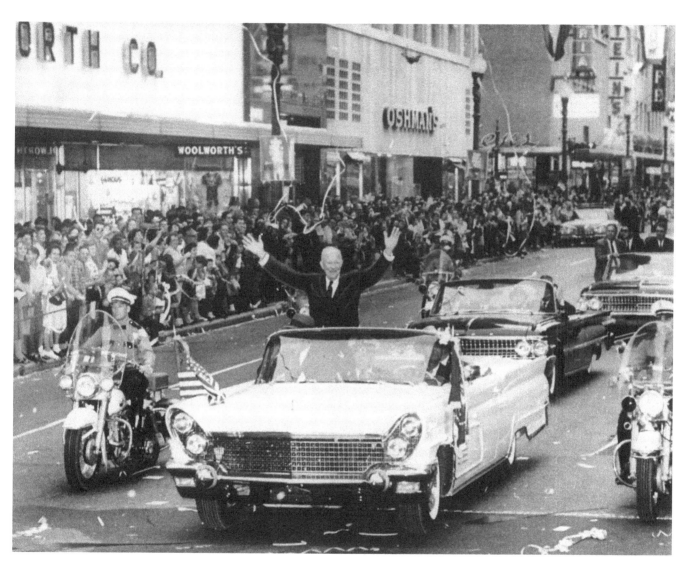

President Dwight D. Eisenhower's visit to Houston, October 1960.

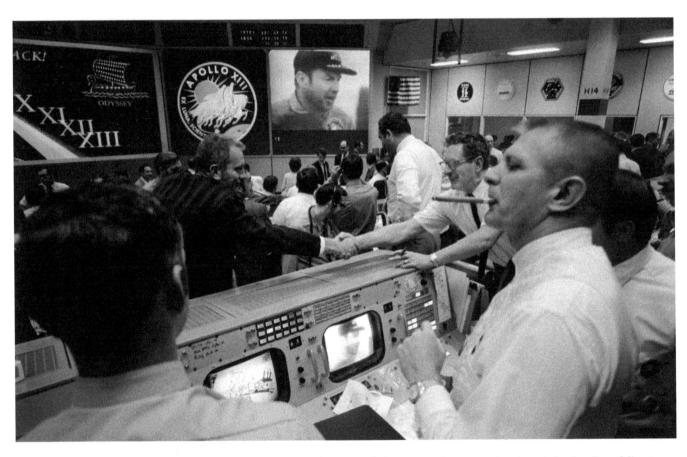

NASA personnel in Mission Control at the Johnson Manned Spacecraft Center watch ceremonies aboard the *Iwo Jima* following the splashdown of Apollo 13 on April 17, 1970.

NOTES ON THE PHOTOGRAPHS

These notes, listed by page number, attempt to include all aspects known of the photographs. Each of the photographs is identified by the page number, a title or description, photographer and collection, archive, and call or box number when applicable. Although every attempt was made to collect all data, in some cases complete data may have been unavailable due to the age and condition of some of the photographs and records.

II **FARMERS' MARKET**
Houston Public Library
Houston Metropolitan Research Center
Houston Collection
157-274

VI **HARRIS COUNTY COURTHOUSE**
Houston Public Library
Houston Metropolitan Research Center
HMRC Collection
114-815

X **SAN JACINTO STREET BRIDGE**
Houston Public Library
Houston Metropolitan Research Center
HMRC Collection
114-717

2 **MAIN STREET**
Houston Public Library
Houston Metropolitan Research Center
Houston Collection
157-2535

3 **ST. CLAIR**
Houston Public Library
Houston Metropolitan Research Center
Mss29.1

4 **MARKET HOUSE**
Houston Public Library
Houston Metropolitan Research Center
HMRC Collection
114-715

5 **HARRIS COUNTY JAIL, 1879**
Houston Public Library
Houston Metropolitan Research Center
HMRC Collection
114-801

6 **JEDIDIAH PORTER WALDO HOME**
Houston Public Library
Houston Metropolitan Research Center
HMRC Collection
114-709

7 **COTTON EXCHANGE**
Houston Public Library
Houston Metropolitan Research Center
HMRC Collection
114-741

8 **U.S. POST OFFICE, 1888**
Houston Public Library
Houston Metropolitan Research Center
HMRC Collection
114-814

9 **THE HENRY SAMPSON HOME**
Houston Public Library
Houston Metropolitan Research Center
HMRC Collection
114-689

10 **COTTON EXCHANGE**
Houston Public Library
Houston Metropolitan Research Center
HMRC Collection
114-741

11 **GRAND CENTRAL STATION**
Houston Public Library
Houston Metropolitan Research Center
HMRC Collection
114-888

12 **VOLUNTEER FIREMEN**
Houston Public Library
Houston Metropolitan Research Center
Houston Fire Department Collection
364-53

13 **ST. JOSEPH'S INFIRMARY**
Houston Public Library
Houston Metropolitan Research Center
Bank of the Southwest/Schlueter Collection
100-534

14 **HEIGHTS BOULEVARD IN HOUSTON HEIGHTS**
Houston Public Library
Houston Metropolitan Research Center
HMRC Collection
114-757

15 **KIAM'S CLOTHING STORE**
Houston Public Library
Houston Metropolitan Research Center
HMRC Collection
114-765

13 **THE HOUSTON ELECTRIC RAILWAY CO.**
Houston Public Library
Houston Metropolitan Research Center
Litterst-Dixon Collection
1248-3287

42 PRESIDENT TAFT'S
PROCESSION
Houston Public
Library
Houston
Metropolitan
Research Center
Progressive Houston,
Vol. 1, Nov. 1909

43 HOUSTON FIRE
DEPARTMENT'S
CENTRAL STATION
Houston Public
Library
Houston
Metropolitan
Research Center
Houston Fire
Department
Collection
364-667

44 CITY AUDITORIUM
Houston Public
Library
Houston
Metropolitan
Research Center
Litterst-Dixon
Collection
1248-3062

45 HOUSTON GAS
COMPANY
Houston Public
Library
Houston
Metropolitan
Research Center
Litterst-Dixon
Collection
1248-1885

46 J. S. BOWSER
LIVERY
Houston Public
Library
Houston
Metropolitan
Research Center
Business Album of
Houston Collection
145-117

47 MOSEHART AND
KELLER CARRIAGE
FACTORY
Houston Public
Library
Houston
Metropolitan
Research Center
San Jacinto
Museum of History
Collection
200-413

48 STELZIG'S SADDLERY
Houston Public
Library
Houston
Metropolitan
Research Center
Business Album of
Houston Collection
145-129

49 THE DIXIE THEATRE
Houston Public
Library
Houston
Metropolitan
Research Center
Business Album of
Houston Collection
145-159

50 AMERICAN LAUNDRY
Houston Public
Library
Houston
Metropolitan
Research Center
Business Album of
Houston Collection
145-106

51 R. WHITE
MANUFACTURING
CO.
Houston Public
Library
Houston
Metropolitan
Research Center
Business Album of
Houston Collection
145-107

52 W. KEATING
CRYSTAL POOL
PARLOR
Houston Public
Library
Houston
Metropolitan
Research Center
Business Album of
Houston Collection
145-74

53 HOUSTON CANDY
KITCHEN
Houston Public
Library
Houston
Metropolitan
Research Center
Business Album of
Houston Collection
145-148

54 BOXED FIGS
Houston Public
Library
Houston
Metropolitan
Research Center
Bank of the
Southwest/Schlueter
Collection
100-950

55 DAVE KAPLAN'S
STORE
Houston Public
Library
Houston
Metropolitan
Research Center
Houston Collection
157-1079

56 LEVY BROS. DRY
GOODS
Houston Public
Library
Houston
Metropolitan
Research Center
Business Album of
Houston Collection
145-138

57 DRS. BURKEY AND
BURKEY
Houston Public
Library
Houston
Metropolitan
Research Center
Business Album of
Houston Collection
145-98

58 NEW CAPITOL
HOTEL
Houston Public
Library
Houston
Metropolitan
Research Center
HMRC Collection
114-694

59 TRAVIS ELEMENTARY
SCHOOL
Houston Public
Library
Houston
Metropolitan
Research Center
Litterst-Dixon
Collection
1248-3313

60 DRAUGHON'S
PRACTICAL
BUSINESS COLLEGE,
1910
Houston Public
Library
Houston
Metropolitan
Research Center
Business Album of
Houston Collection
145-100

61 TELEPHONE
COMPANY
EMPLOYEES
Houston Public
Library
Houston
Metropolitan
Research Center
HMRC Collection
114-544

62 SWEENEY LOAN
COMPANY
Houston Public
Library
Houston
Metropolitan
Research Center
Business Album of
Houston Collection
145-89

63 STAFFORD
HARRISON'S
BARBERSHOP
Houston Public
Library
Houston
Metropolitan
Research Center
Mss 281-37

64 HOUSTON POST
BUILDING
Houston Public
Library
Houston
Metropolitan
Research Center
Business Album of
Houston Collection
145-156

65 POST CLOCK
Houston Public
Library
Houston
Metropolitan
Research Center
Litterst-Dixon
Collection
1248-3233

66 DINNER AT
BENJAMIN J.
COVINGTON HOME
Houston Public
Library
Houston
Metropolitan
Research Center
Harrison Family
Collection
Mss 170

94 TEXAS CO. (TEXACO) STATION
Houston Public Library
Houston Metropolitan Research Center
Litterst-Dixon Collection
1248-3168

95 W. D. CLEVELAND AND SONS
Houston Public Library
Houston Metropolitan Research Center
Litterst-Dixon Collection
1248-3157

96 HOUSTON FIRE DEPARTMENT
Houston Public Library
Houston Metropolitan Research Center
Houston Fire Department Collection
364-506

97 GOOSE CREEK OIL FIELD
Houston Public Library
Houston Metropolitan Research Center
Bank of the Southwest/ Schlueter Collection
100-479

98 TRAVIS AVENUE
Houston Public Library
Houston Metropolitan Research Center
San Jacinto Museum of History Collection
200-319

99 RIVER OAKS
Houston Public Library
Houston Metropolitan Research Center
HMRC Collection
114-1341

100 YE OLDE COLLEGE INN
Houston Public Library
Houston Metropolitan Research Center
Litterst-Dixon Collection
1248-2785

101 COTTON EXAMINERS
Houston Public Library
Houston Metropolitan Research Center
Litterst-Dixon Collection
1248-2802

102 THE HOUSTON ELECTRIC COMPANY
Houston Public Library
Houston Metropolitan Research Center
HMRC Collection
114-1317

103 SIGN PAINTER
Houston Public Library
Houston Metropolitan Research Center
HMRC Collection
114-1321

104 TEXAS AVENUE
Houston Public Library
Houston Metropolitan Research Center
San Jacinto Museum of History Collection
200-310

105 MAIN STREET, 1925
Houston Public Library
Houston Metropolitan Research Center
San Jacinto Museum of History Collection
200-323

106 TRAVIS STREET
Houston Public Library
Houston Metropolitan Research Center
San Jacinto Museum of History Collection
200-554

107 AUTOMOTIVE EVENT
Houston Public Library
Houston Metropolitan Research Center
Bank of the Southwest/ Schlueter Collection
100-1088

108 STATUE OF SAM HOUSTON
Houston Public Library
Houston Metropolitan Research Center
San Jacinto Museum of History Collection
200-484

109 WEINGARTEN'S GROCERY
Houston Public Library
Houston Metropolitan Research Center
Litterst-Dixon Collection
1248-2993

110 LUNA PARK
Houston Public Library
Houston Metropolitan Research Center
Litterst-Dixon Collection
1248-2988

111 PORT HOUSTON
Houston Public Library
Houston Metropolitan Research Center
San Jacinto Museum of History Collection
200-58

112 THE MARGARET LYKES
Houston Public Library
Houston Metropolitan Research Center
Litterst-Dixon Collection
1248-1601

113 CARGO BEING UNLOADED
Houston Public Library
Houston Metropolitan Research Center
San Jacinto Museum of History Collection
200-42

114 THE HOUSTON CHRONICLE
Houston Public Library
Houston Metropolitan Research Center
San Jacinto Museum of History Collection
200-127

115 TEXAS AVENUE REPAIR
Houston Public Library
Houston Metropolitan Research Center
San Jacinto Museum of History Collection
200-456

116 THE METROPOLITAN THEATRE
Houston Public Library
Houston Metropolitan Research Center
Alfred Finn Collection
19-425

117 JAMES BUTE PAINT CO.
Houston Public Library
Houston Metropolitan Research Center
Litterst-Dixon Collection
1248-3002

118 GRADUATION DAY
Houston Public Library
Houston Metropolitan Research Center
Bank of the Southwest/Schlueter Collection
100-186